Botanical Illustration Course

with the Eden Project

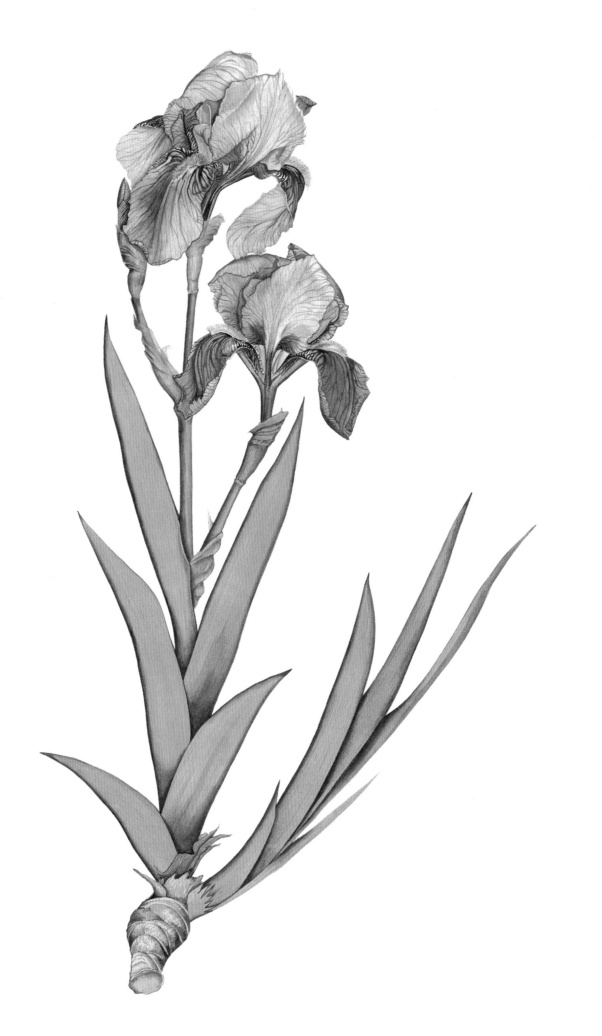

Botanical Illustration Course

with the Eden Project

Rosie Martin & Meriel Thurstan

BATSFORD

First published in the United Kingdom in 2006 by
Batsford
151 Freston Road
London W10 6TH

An imprint of Anova Books Company Ltd

ISBN 9780713490053

A CIP catalogue record for this book is available from
the British Library.

15 14 13 12 11 10 09 08 07 06
10 9 8 7 6 5 4 3

Reproduction by Classicscan
Printed and bound in China by WKT Co. Ltd

This book can be ordered direct from the publisher at the website:
www.anovabooks.com, or try your local bookshop

Distributed in the United States and Canada
by Sterling Publishing Co.,
387 Park Avenue South, New York, NY 10016, USA

Illustration page 2: Tall Bearded Iris
Ilustration page 3: Viola 'Green Goddess'
Illustration, opposite: Iris foetidissima

Contents

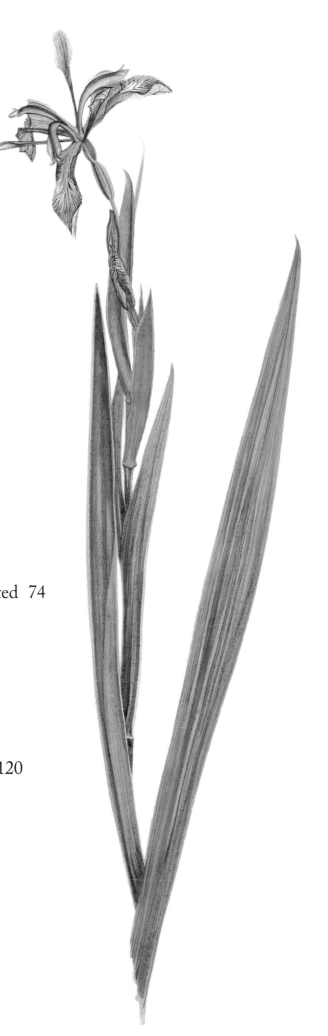

Foreword

Since its inception art has been an important part of the Eden Project as a means of interpretation of its mission to show the importance of plants to people. The visitor to the project sees many different forms of art, each one reinforcing the message of Eden. One of the oldest and most used methods of interpretation of botany has been through drawing and painting. It was therefore highly appropriate that early in its history Eden would organize a course in botanical illustration. I know from the enquiries I have frequently received throughout my career that there are many people wishing to learn how to paint or illustrate plants. This desire has been met for some lucky participants in the course that was coordinated by Rosie Martin and Meriel Thurstan.

Eden also must be unique among contemporary new botanical projects in having a Florilegium Society that is recording so well the wonderful diversity of plants that are growing there. The details of plant structure can be so much better revealed through illustrations rather than by photographs. That is why I and so many other botanists illustrate our technical works with botanical illustrations rather than photographs. This means that there is always a demand for good illustrators.

It is wonderful that the lessons learned in the botanical illustration course at Eden have been brought together here into a book that will be of great use to those budding botanical artists who are unable to attend future courses. An aspect that I really like about this book is that in addition to the illustrations by the authors, it contains many examples of work by students of the Eden course. This will surely encourage many other people to follow the guidelines given here and try to learn the art of botanical illustration.

This honest book, which shows both the successes and failures of taking up botanical art, will be a great encouragement to many would-be illustrators, whether you want to try your skills in this field just for fun or have professional ambitions. Here is a much-needed guide for botanical illustration.

Professor Sir Ghillean Prance FRS, VMH
Former Director of the Royal Botanic Gardens, Kew
Scientific Advisor to the Eden Project

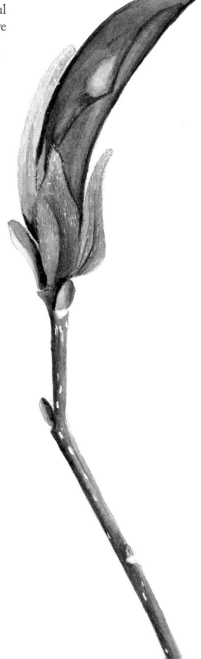

Right: Magnolia bud

Letter from Tim Smit

Our aim when we founded the Eden Project in 2000 was to remind people of the vital part plants play in all our lives. What was once a barren Cornish clay pit is now bursting with plants from all over the world, and is one of the most visited places in the United Kingdom.

The Project is owned by the Eden Trust and all surpluses go to the Trust to further its educational, environmental and scientific aims. We run special educational programmes for students of all ages, our goal being to inspire people to explore their world afresh.

Meriel Thurstan has been part of the Eden team from its modest beginnings at Heligan, and is a pivotal member of the Eden Friends scheme, to which she brings her considerable administrative skills. Much more interestingly, she is a passionate and skilful botanical artist whose illustrations have appeared in every issue of the Friends' award-winning quarterly magazine. She also runs the annual botanical art exhibition for the Cornwall Garden Society's Spring Show.

Meriel is a founder member of the Eden Project Florilegium Society, a group of artists who study and record through the seasons some of the wealth of plant material at Eden, providing a crucial and enduring archive for the Trust. Among the various talks, courses and events provided for the Friends, botanical illustration has proved extremely popular and has inspired many new artists.

Rosie Martin, who was one of the first tutors of these courses, is an artist and designer living in Totnes, Devon. Eden's first year-long Diploma Course in Botanical Illustration, organised by Meriel and tutored by Rosie, was in 2004.

I never cease to be amazed at the vast range of skills we have managed to attract to Eden. This superb book, a collaboration between Meriel and Rosie, arose out of the course and is the culmination of a fascinating year. I feel sure that anybody who reads it is well on the way to becoming a botanical artist – possibly even me!

Tim Smit
Co-founder and CEO, The Eden Project

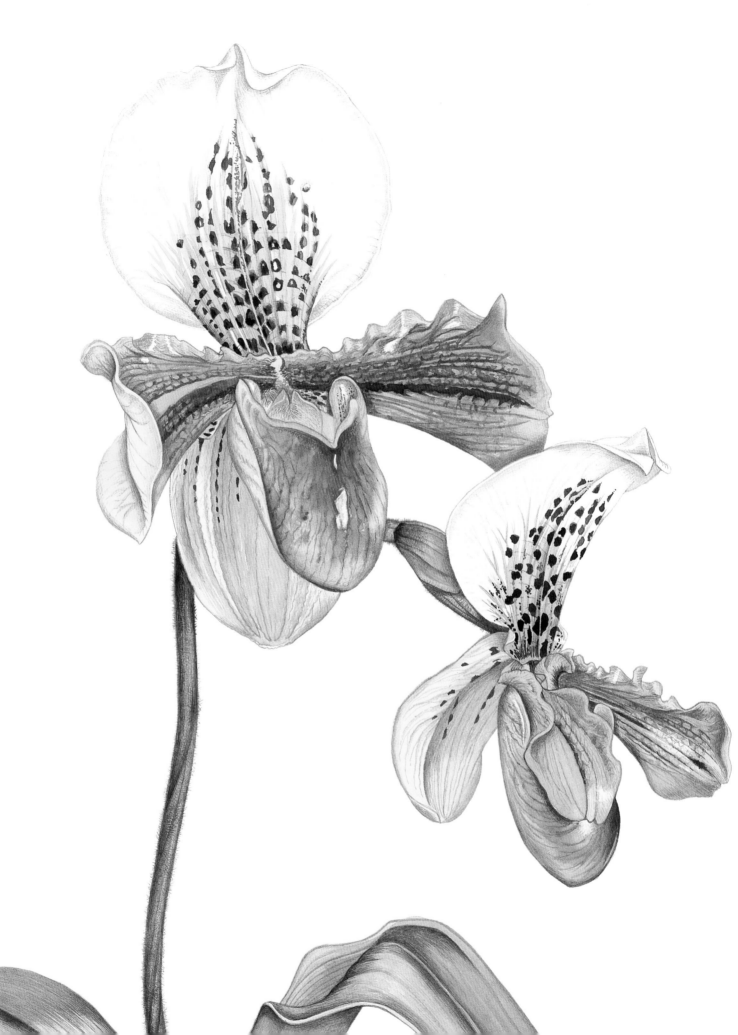

Introduction

The earliest known botanical illustrations are in a series of Egyptian limestone bas-reliefs carved into the wall of the Great Temple of Tuthmosis III at Karnak and date from around 1450 B.C. Nearly three thousand years later the first herbals were made, but little evidence has survived of botanical illustration from those intervening years, although ancient Greek and Roman chroniclers wrote extensively about botany, providing written evidence of illustrated herbals having been produced which sadly no longer exist. Since then it has fascinated all manner of mankind – monks poring over their repeatedly copied (and therefore often unrecognisable) drawings, Dutch Old Masters and their cornucopias of coveted flowers and fruit – encouraged by plant hunters like Sir Joseph Banks who took artists with him on his voyages round the world to record and assist the correct identification of his botanical specimens. Botanical illustration is still widely regarded as being vastly superior to photography in this respect.

There has been a remarkable revival in this art form in recent years, not least of all at the Eden Project, home of 'the only jungle in captivity' and where plants from all over the world are to be found. This book is based on Eden's year-long Diploma Course in Watercolour Botanical Illustration, organized by Meriel Thurstan and taught by Rosie Martin, and many of the illustrations are taken from the students' coursework.

Rosie is a professional artist whose work includes botanical painting, watercolour landscape, figure drawing and textile design, engaging in both solo and mixed exhibitions. She holds a Gold Medal from the Royal Horticultural Society for botanical illustration. She was elected a member of the Society of Botanical Artists in 1990, is a founder tutor of Dartington Flower Painters and is artist in residence for several organisations.

Rosie trained at Leeds College of Art and St Martin's School of Art in London where she was awarded a first class honours degree in textiles, and after graduation worked for several years in hand-painted mono-prints, first for the fashion, ballet and theatre markets, then in interior design. Her clients include Jean Muir, for whom she has produced textiles and interior design prints, David Bowie, Sir Anthony Caro and Christian Dior.

Although there are some extremely pleasing botanical paintings in other media, watercolour is the most widely used medium for botanical illustration because it facilitates a lightness of treatment for the subject and a delicacy in portraying a plant's characteristics accurately. Its other qualities are clarity, transparency, translucence, luminosity and freshness.

The intensive course outlined in this book sets out to teach and develop the skills necessary for the botanically accurate and aesthetically pleasing portrayal of plants in watercolour. Through a series of exercises, including as much general visual education as possible, this book provides the building blocks for students to progress towards realistically competent levels.

Rosie and Meriel believe that any person who is willing to learn and prepared to work hard can achieve the skills essential for accurate illustration of plants in watercolour within the context of botanical painting. They do not provide a 'painting by numbers' system in which you will simply copy other people's styles and methods. Although reference to other artists' work is of the greatest benefit to a beginner, it is the reader's style that has to be encouraged to develop, and throughout the book suggestions are made of different methods you might like to try in order to discover your own preferences.

Happy painting!

Left: Detail of Slipper Orchid (*Paphiopedilum* cultivar) shown in full on page 60. Note the fine hairs on the stem (see chapters 7 and 13).

Materials and equipment

When setting yourself up with the tools of your trade, strive for quality, not quantity. For instance, an expensive paint box with every conceivable colour is not going to make you an expert botanical artist, but a small selection of the finest artists' watercolours you can afford is going to give you every advantage and enhance your work.

Similarly, you don't need the full range of every watercolour brush ever made, but what you buy needs to be the finest quality.

Listed below are the basic necessities for a botanical artist, as well as the various bits of useful equipment that will make your task easier. You don't need to buy them all at once. You may even find that you can do without some things or can improvise more cheaply.

But if buying, always buy the best you can afford – your work deserves it.

Watercolours

Buy artists' quality paints. Student ranges may seem better value, but your work will benefit from better quality. Many art suppliers sell empty paint boxes that you can fill with your own choice of colours.

The colours listed below are sourced from Schminke-Horadam (the equivalent Winsor & Newton artists' quality colours are also listed) and are the minimum requirement for a botanical painter. The pigments are finely ground and chosen for their clarity, durability and brilliance; they are particularly good for all types of flower painting. Watercolours come in pans, half-pans and tubes. It is a matter of personal preference which you buy. If there is no good art supplier near you, it is possible to order a huge range of materials at most competitive prices either from a selection of catalogues or over the Internet. (See Useful Information on page 141.)

In art suppliers' catalogues there are numerous colour charts for different watercolours. If you prefer to buy other makes of paint, try to ensure that they correspond as closely as possible with the colours listed here. It is important to do this as the colours given are based on a limited, mainly primary palette, which follows the laws of colour theory rather than 'my favourite palette'. European manufacturers, such as Schminke-Horadam, Holbein, Lefranc & Bourgeois, Sennelier and Old Holland Classic supply strong, lively paint colours and offer a good range of vibrant pinks, purples, reds and oranges.

The most basic colour palette for botanical illustration is given here, but with experience you will expand this to include your own personal favourites. You will notice that we do not mention black. This is because you get a far better colour if you mix your own (see page 42).

Right: A sensitive pencil drawing of Chinese Lantern (*Physalis alkekengi*) giving a clear indication of the characteristics of the ripened fruit and the lacy, web-like structure of the calyx as it decays in late autumn.

Schminke-Horadam
- Chrome yellow lemon, no lead, or pure yellow
- Indian yellow or gamboge gum modern
- Permanent red orange or vermilion
- Alizarin crimson or madder red deep
- Ultramarine finest or ultramarine blue
- Prussian blue or Paris blue
- Sap green
- Brilliant blue violet
- Brilliant purple
- Titanium white
- Permanent Chinese white

Winsor & Newton (Artists' quality)
- Winsor lemon or transparent yellow
- Indian yellow or gamboge genuine
- Permanent alizarin crimson or permanent carmine
- Scarlet lake or vermilion hue
- French ultramarine
- Prussian blue or Winsor blue (green shade)
- Permanent sap green
- Winsor violet
- Permanent rose
- Titanium white (opaque white)
- Chinese white

Paper

Watercolour paper for botanical work should be acid free. It can be bought in a block or in separate sheets. Watercolour paper comes in a variety of surfaces from HP (hot pressed, which is very smooth) to Rough (heavily textured). There are also a number of different sizes, weights and shades available.

Most botanical painters use HP paper. The usual weight is 140 lb (300 gsm), as it is thick enough not to need stretching provided you don't paint too wet. Many papers also come in 300 lb (640 gsm) for those who like to work on a more board-like surface. Painters develop their own styles requiring different surfaces. Some more experienced artists prefer to use illustration board or vellum, but it is not recommended until you have learned to paint on watercolour paper.

There are many high quality watercolours papers available. These include Arches Aquarelle (probably the most widely used of all), Fabriano Artistico, Schoellershammer, Winsor & Newton Cotman, RWS, Saunders Waterford, Lana Aquarelle and Sennelier. Check at the time of purchase whether it is acid free. Packs of five sheets by mail order are good value and suppliers will usually cut paper to size for you if you specify your requirements. Colours vary, from quite a strong cream to pure white. Paper is best stored flat, not rolled.

Different papers cater for different painting styles; for instance, papers such as Arches and Sennelier (even when HP) will allow a certain amount of surface water manipulation, whereas Fabriano 5 and Schoellershammer favour small, stippled brush strokes. Experience will teach you which paper suits your style.

It is probably best to start with a widely used paper such as Arches (try both Not and HP). As your style develops you will discover other surfaces and make a more personal choice.

You will also need:

A small watercolour pad or sketchbook for colour testing and exercises.

A cheap A3 layout pad for making general working drawings. Because it has a smooth, lightweight (50 gsm) and decisive surface, this promotes a more relaxed approach in the artist, which in turn leads to more spontaneous preliminary drawings. Many beginners (and often more experienced artists) will 'tense' when presented with a smart, expensive sheet of watercolour paper. Practising on cheap paper, which is neither critical nor expensive, can help you become more relaxed and self-assured about the whole process.

Vellum

Over the last few years this ancient favourite has come back into vogue. Some of the best artists produce glowing, jewel-like paintings on vellum, which is a natural material, being made of animal skin such as calf or sheep. It is expensive and needs treating prior to use; some specialist shops sell it ready prepared. All drawing must be transferred to the vellum as the surface can't take rubbing out.

This surface really favours a much drier style of painting, although paint can be scraped or lifted off fairly successfully. Small, stippled brush strokes suit vellum best; wet washes just look streaky and messy.

Brushes

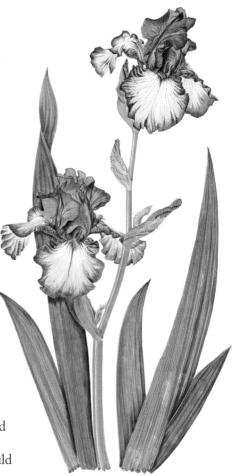

Kolinsky sable brushes are the best for botanical painting as they have good points, hold lots of paint and are very versatile. Even large Kolinsky sable brushes have points that are as fine as a size 0. The best types of brush for botanical illustration are rounds and miniatures.

The Series 7 Winsor & Newton range of brushes is excellent for a beginner. They are very high quality and are consistent.

Other good makes are da Vinci Maestro series 10 and 35, Raphael, Escoda and Isabey. There are also many makes of miniature or spotter brushes, which are used for applying stippled paint. Artists who favour using very little water would use such brushes, which are small, short and round.

The minimum requirement is four brushes, sizes 0, 2, 6 and 8. For extremely detailed work you may eventually need a 3/0 or a 4/0. The No. 8 can be a sable/synthetic mix, as large pure Kolinsky sable brushes are very expensive. A cheap synthetic brush is also useful for mixing paint.

Good art shops provide a container of water so you can check the point of a brush before buying. If one is not provided it is usually quite acceptable to ask.

Other equipment

You will also need:
- Two large jars for clean water – one to rinse your brush, the other to paint with.
- Magnifying glass – we recommend using a free-standing one, so you can paint fine detail accurately. A hand-held one can also be useful.
- Tilted drawing board large enough to take your largest effort or more than one piece of work at the same time – you will discover which angle suits you best. Many art suppliers sell folding easels for use on a table. If considering one of these, check the angles available. Some artists prefer to work with it relatively flat, others almost upright.
- Absorbent paper or rag for blotting your brush or spilled paint.
- Masking fluid – used to mask out inaccessible areas such as tiny filaments or speckle markings. This comes with an applicator, but you could use an old, small synthetic brush or the sharpened quill of a feather. Once used with masking fluid, a brush is ruined for any other purpose.
- Pencils in a good range from hard to soft (6H to 3B). Harder pencils give a much lighter range of tones than the softer ones. Hard pencils range from 9H (very hard) to H (hard); soft pencils from B (soft) to 9B (very soft). We recommend the middle strengths 6H to 3B because these will give an adequate range of tones.
- Eraser (putty or hard white such as Staedtler or Faber Castell). For detailed eraser control, cut off a small piece or shave your eraser to a point. Some art shops and mail order suppliers sell special eraser 'pencils' which have points and can be sharpened.
- A clean feather to brush off eraser sweepings (insert the quill end into a cork for ease of handling).
- A knife or pencil sharpener.
- Some form of 'third arm' apparatus either to hold or spike your specimen. Adjustable 'third arms' can be bought in model-makers' shops and art suppliers, or you could make your own from oasis, crumpled chicken wire, a bottle weighted with sand or simply a bulldog clip on your drawing board or easel. There are many ways of controlling your specimen – be inventive!
- A palette for mixing paints. China palettes are best because unlike plastic they won't stain, but you could use an ordinary white plate.
- Dividers for accurate measuring and transferring measurements to the paper. Your dividers need very fine points, and for this reason nautical chart dividers are not suitable.
- Ruler.
- Masking tape.
- Razor blade, craft knife or scalpel for dissections.
- Microscope (optional).
- Digital camera (optional).

Left: Tall bearded Iris (*Iris* 'Patina').

Studio practice – how to set up your studio at home

When thinking about how to set up your studio, it is important to consider your own working methods first. For instance, you need to discover whether you prefer to work by artificial light or whether you are happy using only natural light. Try both and see how you get on, but remember to position yourself so as not to work in your own shadow. It is customary for botanical subjects to be lit from the left, but if you are left-handed you will need the light from the right.

Normal light bulbs cast a yellowish glow, which could affect your choice of colours. Consider using a daylight bulb instead. An adjustable desk lamp can be an advantage, to light either your work or your specimen, or both.

Think about any distractions that might occur and how they will affect you. It is important to minimize interruptions of any kind. Some people like to work in complete silence, while others prefer to play music or listen to the radio. You will discover which you prefer.

Try to arrange to have a room or part of a room for yourself; clearing work off the kitchen table at mealtimes makes good studio practice almost impossible.

Sit comfortably, with your back supported. A typist's chair with adjustable height is beneficial.

Position your materials close at hand and consider where and how to place your specimen. You might need something white behind it to screen out any clutter.

In Chapter 1 you will be starting to draw, and it is during this period that you will see just how your environment meets your requirements. Above all, be comfortable... and calm! Take regular breaks to review your work and relax yourself.

The specimen may be prone to change. It may wilt, or die completely. Does your time frame correspond with that of the specimen? If not, what steps can you take?

Before you start, try to consider the wider implications:
How much time can you give to a painting?
Is it enough for the job in question?
What else is taking place in your life (barring the unseen)?
Will your lifesize specimen fit on to your chosen paper?
Have you planned the painting through from start to finish?
The more organized you are at the outset, the better the end result.

The life of cut specimens can be extended by various means: sugar in the vase water; storage in a cool, dark place when not being painted; spraying with water, to mention but a few. Be inventive, and think constructively about your own plant. There are so many factors that affect botanical paintings and artists' own working methods vary so much. A fast painter will complete a picture using the same specimen, whereas a slow painter might have to resort to replacing the specimen, or using working drawings or photographs, colour swatches and so on.

Think of any aids to get you from start to finish if the whole specimen is lost and it turns out to be the only one available. There are many tales of botanical painters who, having started a painting have had, for various reasons beyond their control, to store the painting away carefully until the following year when another specimen was obtainable.

Keep your work clean and avoid touching the paper. The minutest trace of the natural oils from your skin can affect the performance of the paint. Some artists use a sheet of clear plastic laid over their work, with a hole cut in it through which they paint. Or you might simply place a sheet of plain paper under your hand.

Arrange your paint box so it is always in the same position, so that you get used to where and what all your colours are. You might find it helpful to make a colour chart of the paints with their names, which is then fixed to the inside of the lid.

Take care of your brushes. After use, wash them in clean water and store upright in an airy place. Never leave them standing in water. If the brush tip becomes distorted, either dip it in very hot water and pull gently into shape, or use soap to give it the correct shape, allow to dry and then rinse well. If you carry your brushes around, first wrap them in corrugated card to protect the hairs.

Planning your studio, equipment and method of working at this stage is never time wasted. Just like any other artisan, you need the correct tools for the job and the correct environment in which to carry it out. But your perceptions and needs are bound to vary with experience, and in due course you will discover what suits you best in terms of both comfort and efficiency, so that you can paint in a relaxed frame of mind, with the minimum of distractions, and give pleasure to both yourself and the people who view your paintings.

Right: Place a sheet of white paper behind a white subject to help identify areas of shadow. Identify areas of reflected colour – these may not be relevant to the accurate portrayal of your subject and your lighting may need to be adjusted.

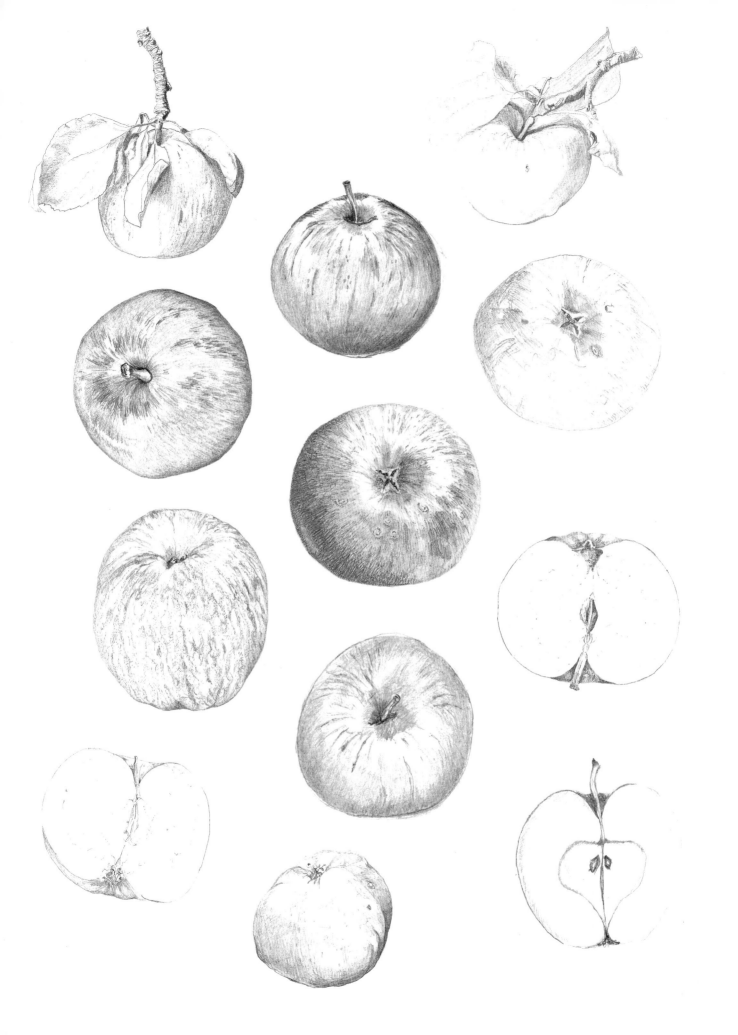

1. Pencil Drawing

In this chapter we will show you how to develop observational techniques, working in pencil to draw a specimen in line and tone. Because a pencil is such a basic tool, many people fail to explore its possibilities. But pencil, with the wide range of tone it offers, is a fantastic medium for developing your understanding of form. Before you can move into colour, you must first discover the shapes and tonal patterns that are the basis of any good botanical illustration.

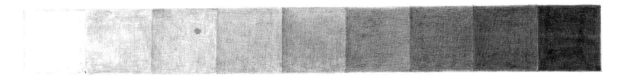

Tonal test strips exercise

This exercise will heighten your awareness of the capability of both you and your pencils. Tonal strips are test strips that can help you understand just what your pencil can do, and they are useful tools when you come to evaluating and translating the tonal strengths in any given specimen.

Make a tonal strip for each pencil you are using. It is a good idea to do this in your sketchbook so that you can keep a record showing the range of tones each pencil can give. Working across the page, produce blocks of tone, shading lightly at first and then working progressively darker as you move across the page. (See the diagram above.)

Experiment with different types of shading: use hatching, cross-hatching or non-directional pencil strokes and see how this affects the tones you produce and the smoothness of the tonal transitions. Non-directional shading emulates watercolour techniques in that it blends smoothly from light to dark without showing any lines. The movement of your hand is almost like a circular, burnishing movement, which has the effect of smoothing out the shading.

Left: As these studies by different students show, the apple has a relatively simple shape, which is ideal for exploring form through markings.

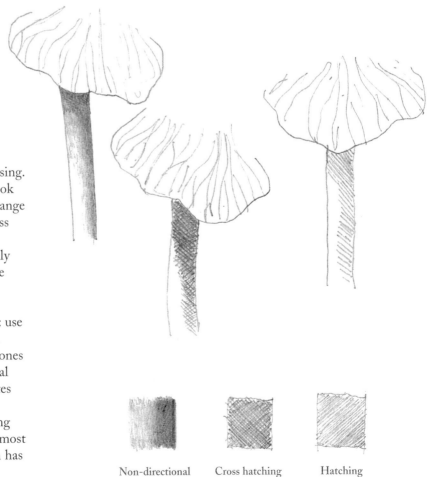

Non-directional Cross hatching Hatching

Above: Examples of different types of shading.

Separating the mid-tones is difficult, but this is an important skill that allows you to identify tones in botanical specimens, using your pencil work from very light to very dark. Many people find that their first attempts at drawing display a lack of contrast, with most of the shading in the mid-tones. Experimenting with tonal test strips enables you to be more adventurous in your drawing, using extremes of light and shade to bring out the tonal contrasts.

Observational drawing

Your first task is to choose an apple and study it. The apple has a relatively simple shape, which is ideal for exploring form-building.

One of the most important lessons you can learn from this introductory chapter is to slow down sufficiently to examine specimens in depth; to look, to understand and not to rush. In order to look harder at a subject, you will find you have to look longer and make a conscious effort to slow down before starting. Really look. Quality of observation always counts far more than quantity in this case.

It is important to tune yourself into observational technique. Simply sitting and quietly contemplating the subject in all its aspects is the best way of getting acquainted. Your knowledge and understanding of the subject will increase many times as a result of close, reflective contemplation. Check your light source, as this too will help you to understand form. If necessary, light your apple with artificial light (table light, desk light or spotlight). Try lighting it from the top, the side or below and consider what difference this makes.

While you are contemplating, ask yourself what sort of form the apple has and where any lumps, bumps and directional changes occur in it. Place the apple in one position and study it. Continue to change its position until you are happy with a particular aspect.

Think about whether the apple is large or small. Use dividers to check its size from top to bottom, from side to side, from its core to its outer points, and transfer the measurements to the paper. Your drawing should be life-size. Try initially to sum up these points without the help of drawing aids, as this will hone your powers of observation. This may take longer but ultimately you will become a better draughtsman.

Right: Use an imaginary clockface or an imaginary segmented sphere like a beach ball to track form through markings.

Don't be confused by surface markings on the fruit. Any surface pattern will usually follow the form of the apple. Use an imaginary clockface divided into four sections to track form through markings, or an imaginary segmented sphere rather like a beach ball. Notice in which sector any marks, blemishes or striations occur. For instance, there may be a blemish at '10 o'clock' or a stripe finishing at '3 o'clock'. This way of looking at your subject will help you to define the exact positions of any characteristics. In the case of an even-coloured fruit such as a Granny Smith, there are no surface markings to guide you, so a clockface approach, radiating from the core, can be helpful.

Blemishes often run contrary to skin pattern and can give a false impression of correct form. Check what you are seeing and consider carefully the visual information that is being given.

Write down a list of adjectives that describe the apple: consider words like hard, soft, shiny, matt, smooth, knobbly, heavily decorated, plain, bright or dull. Keep your word list nearby or in your sketchbook. Then, at regular intervals during your observation and drawing, you can stop to compare your descriptive words with your drawing. Is it soggy, woolly and limp when it should really be crisp, smooth and solid? Do the words match the picture? It can be helpful to look at plants as people: think about characteristics like prickly, suave, sinewy, brittle, craggy, smart, scruffy, bold, shy, obvious, ostentatious, retiring, simple or complex. Apply this exercise to your apple and write down a few words. This list will be invaluable when assessing and creating the correct character and attitude of any plant.

'Profound pencil' and its place in botanical art

The next step, after making your observations, is to begin to explore the concept of line and tone, or shading, to create form. You will need to think about how pencil work can create a three-dimensional effect on a two-dimensional surface (the paper) and explore what works and what doesn't – and why.

'Profound pencil' is what we as artists aim for when using pencil to describe something. As botanical painters we need to develop accurate representations and strive to make every mark count, thus making our pencil interpretation 'profound'. It defines us as draughtsmen and underpins our seeing and doing.

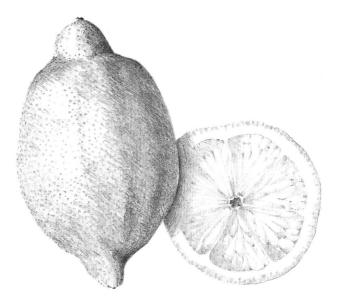

Right: Subtle pencil work has been used to give this lemon a three-dimensional effect, texture and form. Note the contrast in treatment of the skin and the flesh.

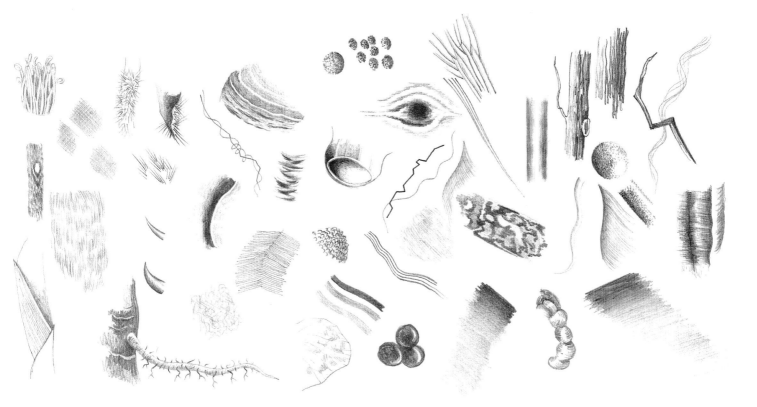

Discover what a pencil can do. See what kinds of marks it will make and what they will convey. You may need to use your pencil sharpener or knife very frequently. Note the difference between a freshly sharpened lead and one where the tip has been smoothed down by use. It can be useful to have several pencils ready sharpened so you can quickly change pencils without losing concentration.

Think about how best to illustrate surface pattern and how you can show form and texture. See how many ways of showing pattern and texture you can discover by making different pencil marks. Try overlaying successively deeper tones from pale grey to deep black, using non-directional shading. You will find that beginning with the light areas and building up tone by tone until the darkest tone is finally reached is similar to layering up tones in watercolour (see chapter 6 for more on this). Experiment by overlaying with a slightly darker tone where shadow falls more heavily or where markings cause darkening or deepening of one tone to another. Detail and decorative markings such as striations, blemishes, holes and pits can be built into the drawing as it progresses, or you can leave these until the very last stages. As you gain confidence, you will naturally select the method you prefer. However, do not be tempted to put in details and embellishments before fully understanding the structure, form and habit. Don't be afraid to make mistakes – trial and error are great teachers.

Above: How many ways of showing pattern and texture can you discover by making different pencil marks?

While you are working, there are four specific areas to consider:

- **Accuracy:** Make sure the viewer understands and recognizes the subject. Botanical subjects are always depicted life-size, unless they are extremely large or extremely small. A large subject could be shown half-size or less, in which case you would mark your drawing x0.5, x0.25, etc. A small subject could be shown twice or three times the size, or more (x2 or x3 and so on).
- **Form:** Make sure the subject's basic shape and three-dimensional image are correct. Nothing is worse than spending hours over a picture only to find that its proportions have been wrong from the beginning.
- **Structure:** Make sure the subject's basic structure and the relationship of one part to another are correct, such as the distance from the core to the edges. Consider the angle at which the specimen is presented and whether the various parts correspond.
- **Character:** For this exercise, sum up the differences between various types of apple (there is a big difference between, say, a 'Russet' and a 'Cox's Orange Pippin'). What are they and how do they help differentiate one cultivar from another? What gives one cultivar its distinct individuality?

Sketchbook work

Start to build up a sketchbook, using a number of plants as your specimens. Include stems and leaves, paying particular attention to leaf types and how they vary, their shapes, undersides, arrangement of veins, edges and so on. You will also be looking at foreshortened shapes and how to make the best of them in compositions (see chapter 2).

Your first task is to examine the basic shapes, structures and positioning of your stems and leaves. Describe the physical features of the plants in words, as you did for your apple, and think about how they apply in visual language. Look for the basic shapes within the plant. Can you see circles, triangles or squares? Make a note of the shapes you identify. Your stems might be shiny, knobbly, sinuous or spiny. The character or habit of the whole plant might be alert, wild, dancing (fuchsias are often seen as 'dance partners'), stilted, stiff, slimy (in the case of some foetid fungi), drooping or entwining (clematis, vines).

Then make preliminary sketches in which you assess the values of your specimens and the relationship of stems to leaves. It is easy to get too involved with detail before an overall assessment of the general design and placement has been made. Do preliminary drawings in your A3 layout paper pad. These allow for quick, summing-up studies, which determine important points such as size, proportion, structure, growth pattern, attitudes, angle, geometric shapes (see chapter 2) and habit of specimens. Layout pads can be used for working out, placing in the format and moving elements around to compose the picture. This involves structuring the angles and proportions, and assessing spatial relationships and negative space (the spaces in between and around the specimen).

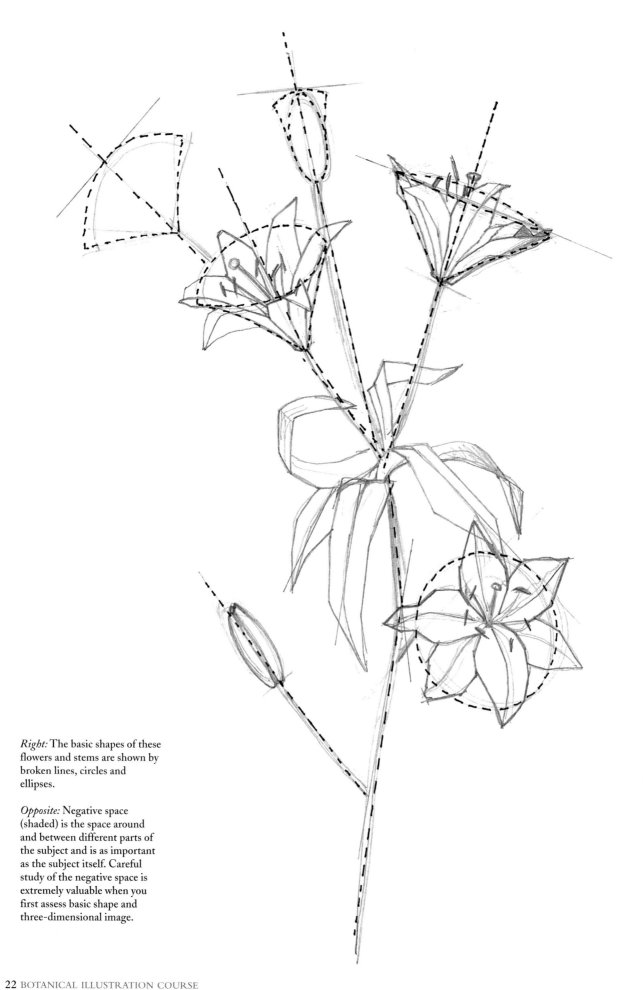

Right: The basic shapes of these flowers and stems are shown by broken lines, circles and ellipses.

Opposite: Negative space (shaded) is the space around and between different parts of the subject and is as important as the subject itself. Careful study of the negative space is extremely valuable when you first assess basic shape and three-dimensional image.

In your preliminary drawings of a leaf, check the overall size and shape, including its widest points and its tips or apexes, and its venation; the leaf bases and how they relate to and join the stem; then the leaf margins or edges, whether unbroken, smooth-sided, or serrated, spiny or jagged. It is very easy simply to overlook the finer points of a leaf and end up misrepresenting a species due to lack of observation and inaccurate recording.

If you have a complicated leaf, such as that of a primrose (*primula vulgaris*) or foxglove (*digitalis purpurea*), taking a photocopy or scan of the leaf can help you to work out the pattern of the veins (see right).

When drawing stems, remember that they are critical to any plant because they support the flowers and are the plant's food carriers. Many a decent painting has been let down by stems that are unrelated to the subject (too thin to be able to support a flower-head, too uneven or simply out of character for the plant). Look at them from different angles and select one from its most favourable aspect to study and draw.

When working in your sketchbook, look closely at leaf and stem joints and plant parts. Make detailed drawings showing such things as where leaf junctions occur and at what intervals – these can be critical characteristics for plant identification. Note the symmetry or asymmetry of the plant parts. Pay particular attention to tone, texture and pattern of your leaf. Note any foreshortened shapes and decide how to manage them within a picture. Don't forget to examine the stem's structure. Stems must not just 'fizzle out'; traditionally they are shown ending in a cross-section to define not only the form but also the structure – hollow, woody, pithy, sappy.

At this early stage, look and record what you see without the use of aids such as dividers and ruler. Although these tools are important to the botanical painter for making precise measurements for identification purposes, as a draughtsman-in-training your aim should be to observe well and try to work things out for yourself in the first instance. As your eye becomes more attuned to observing properly, self-confidence in your own ability to see and record grows too.

Right: Primrose (*Primula vulgaris*). Photocopying or scanning a leaf can help you to work out the pattern of complicated veins.

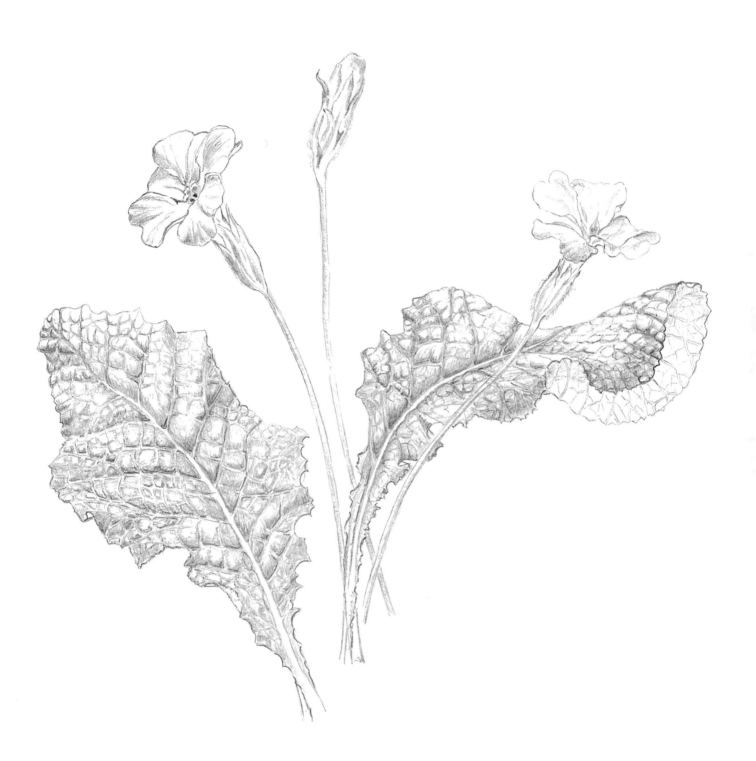

Above: Pencil can be a rewarding medium for a delicate plant such as a primrose. This student's drawing accurately describes the intricate venation of the leaves.

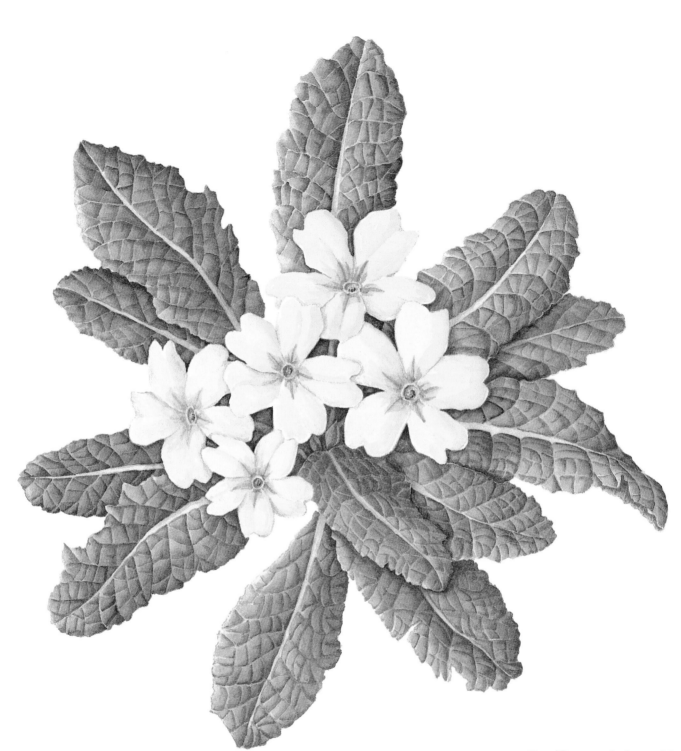

Above: These complex leaves of the primrose (*primula vulgaris*) took four days to paint! This gives an idea of the time many artists invest in botanical painting. The pale yellow flowers really stand out against the dark foliage. The impact would be lost if they were against a white background.

A good quality magnifying glass is a valuable tool at this stage, as it can help to identify areas that are simply too small to see properly with the naked eye. These details need to be portrayed accurately right from the start.

As you continue with your preliminary drawings, it can be useful to keep notes on how your perceptions of your chosen specimens change. Think about whether you are noticing any more about your subject, and whether you are formulating new ways of approaching it. Note down exactly what has changed, why it has changed and how it is different from before.

The value of pencil work

It is worth persevering with your pencil work as it can help with many different aspects of botanical illustration. It will give you ideas about the suitability of different techniques for different specimens. It can also inform your understanding of watercolour practices, as pencil work can be very similar, particularly in relation to light and dark shading.

Pencil can be used to lay out the entire plant, omitting any non-characteristic blemishes that may confuse the work.

Pencil work also gives you the opportunity to explore a technique that is used to perfection by some leading botanical artists, that of 'watercolour over pencil', where all the main tonal areas are rendered first in pencil. (See chapter 12.)

The next stage

Ultimately these initial drawings can be refined and shaded to a desired level and then transferred by various means on to the watercolour paper you plan to use; you could trace the image with graphite carbon paper or use a light-box. An easy and cost-free way of tracing is to fix your layout paper to a windowpane with masking tape, stick your watercolour paper over the top and trace through, using a fairly hard pencil (2H) very lightly indeed. The advantage of tracing is that you still have your initial workings to refer to as you proceed with the painting.

You may choose to draw direct on to your chosen paper, but it is important not to use an eraser too much in the process as this breaks down the surface of the paper. If you are hesitant with drawing direct on to the paper, do some preparatory drawings in your layout pad to familiarize yourself with the specimen first.

Don't be tempted to bypass pencil work. Many beginners might be tempted to skip detailed drawing practice in favour of rushing ahead with applying paint. But there are so many skills to master before you get out your paints, and the simplicity of pencil work can teach you so much. You only have to look at the preliminary sketches by masters such as Leonardo to see that time spent exploring and evaluating your subject is never time wasted.

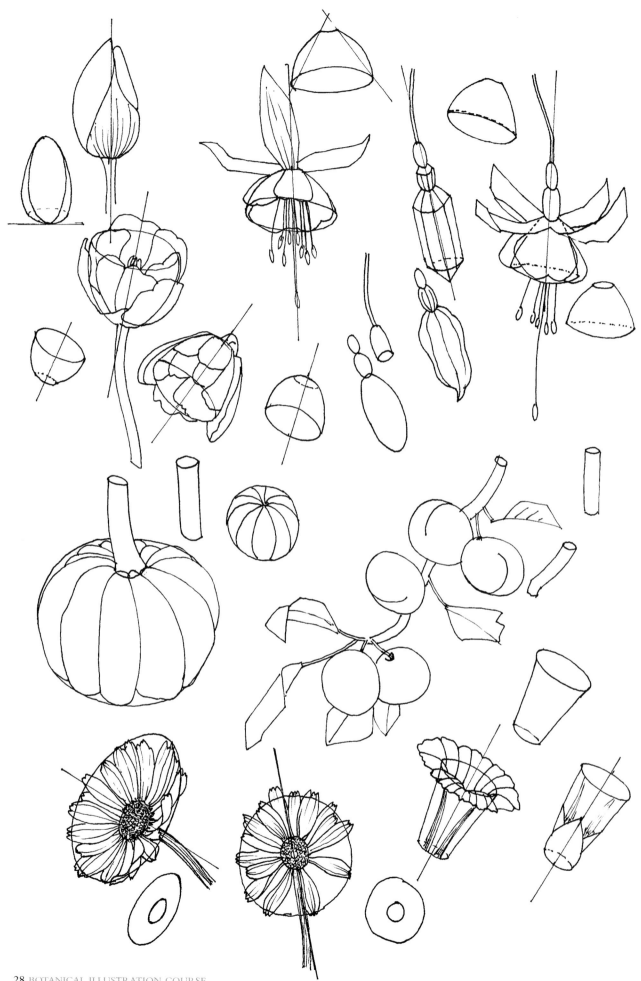

2. Forms in Nature

In this chapter you will be looking closely at the geometric forms that underpin botanical structure, together with foreshortening, cast shadow and overlap, which can create some tricky problems for the botanical artist.

Geometric forms establish the outer and inner spatial volumes of plant parts wherever they appear and can be found in most flower structures – fuchsias, tulips (hemisphere), daffodil, amaryllis, rhododendrons, streptocarpus, convolvulus, azaleas, foxglove (cone), stems (cylinder or tube), and berries, seeds and fruit (sphere) to mention a few – so you have a wide range of specimens from which to select.

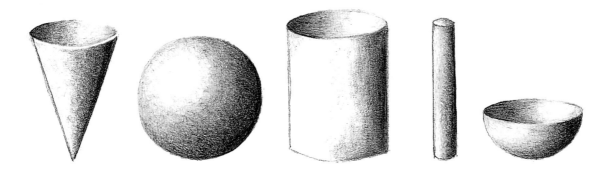

Geometric forms

As part of your practical work, do as much drawing as possible. Draw a cone, a sphere, a cylinder, a tube and a hemisphere, and shade them in. This will help you produce smooth-running, non-directional tone. *An Approach to Botanical Painting in Watercolour* by Anne-Marie Evans gives more information on this (see Further Reading, page 139).

Now take a plant specimen and look for the geometric form. Make a drawing to sum up your specimen quickly and accurately, using very little detail. This drawing should be a combination of geometric forms initially; for instance, a series of cones attached to a stem line (very slim tube) for the lily. Consider its placing on the page and give an indication of the finished layout. When making this quick drawing remember that it is important to get the shape right (see illustration page 22). Look at symmetry and areas where there are variations to the symmetry, such as lumps, bumps, discrepancies and idiosyncratic movements. Build them into the basic shapes – they make character.

Then make drawings to describe form using tonal pencil work, as you practised in chapter 1. Look at the shapes you have drawn to remind yourself how the tones should fall on a three-dimensional form. You can either work up the initial drawing or make another, more detailed one as well.

Left: Geometric shapes that underpin plant forms.

Cast shadow and overlapping

The next stage is to consider those parts of your specimen that appear in the shadow of something else, such as where one petal is behind another, or where leaves cast shadow over other leaves, stems or flowers. Use shading to set these elements in space – whether front, middle, behind or in the distance.

Curling leaves are a good example of cast shadow. Where a leaf curls over, a very deep shadow occurs. If your specimen has curling leaves, look at the depth of shadow and consider how much tone to use. In time you will learn to adjust tone according to the amount needed, but bear in mind that a common difficulty is applying tone dark enough in areas of intense shadow.

Check your tonal chart (from the exercise in chapter 1) for the balance of the number of tones; whether it is too dark, too light or whether it has too many mid-tones. It is really important to practise extending your tonal range as achieved on your pencil chart. Many beginners find it easier to apply tone on charts rather than on their actual drawing.

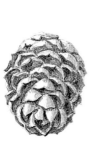
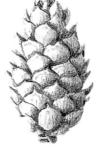

Above: Anthurium andreanum, conifer cones and a dry leaf. The impact of any drawing or painting is often given by the contrast between very dark and very light areas. This is particularly noticeable in the centre of the leaf fold.

Foreshortening

The next matter to consider is that of foreshortening. This is the way in which we represent plants or parts of plants that recede or project towards us, so as to give a correct impression of form and proportion.

Observe how veins follow the form of the leaf, how they join the midrib and what happens to them when they reach the edge of the leaf. Then look at what happens to the veins when the leaf is foreshortened. Note the points at which the midrib disappears and reappears if a leaf is folded. Drying, curled leaves demonstrate extreme foreshortening and intensive shadow. You may find that temporarily showing invisible foreshortened areas, such as disappearing midribs on leaves, is very helpful. Any such lines can easily be erased once the correct position is determined.

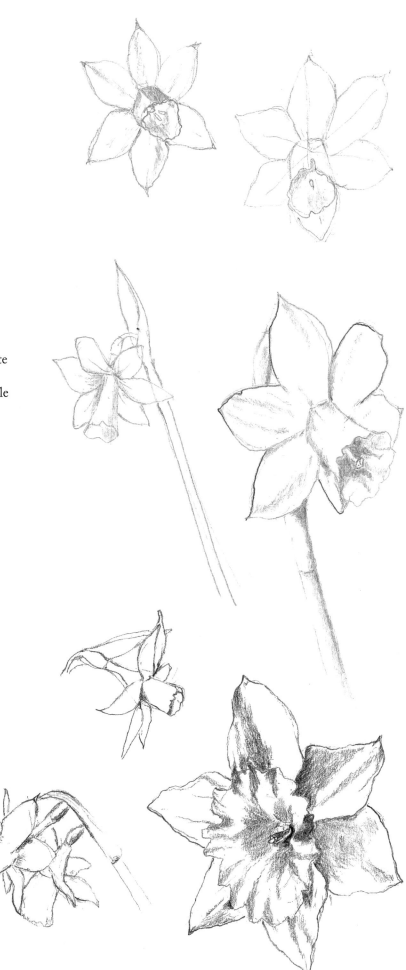

Above: Use light dotted lines to track veins and leaf edges where they disappear. These can be erased later.

Right: Preliminary daffodil drawings explore different forms and angles.

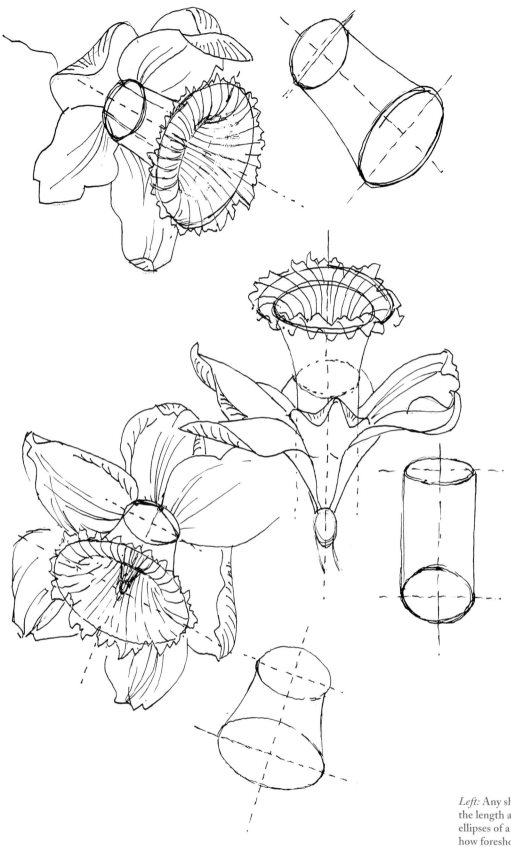

Left: Any shift in viewpoint changes the length and width, circles and ellipses of a daffodil bloom. See how foreshortened petals curl round, come forward or recede.

When looking at tubular flowers, such as a freesia, alstroemeria or lily, you will notice that they all present foreshortening problems as their petals advance and recede. A daffodil is a good flower to work with when tackling the problems of foreshortening, as flowers in the daffodil family often cause artists difficulties. If you examine a daffodil, you will see that the most difficult feature is the foreshortening of petals and how they stand in relation to the rest of the flower – look carefully to see whether they are set at right angles, project forward or are reflexive (curve backwards). Another difficulty relating to foreshortening is the length of the trumpet. Any shift in viewpoint changes the length and width, the circles and ellipses. As with other foreshortening problems, the trumpet often ends up looking too long. This can then be compounded by lengthening the petals around it, resulting in the whole flower being far too long. Make a careful examination of how the flower fits together. You might find it useful to dissect the specimen (see chapter 14).

Representing areas of foreshortening will always remain challenging for any artist. But with increased observational skills, confidence and above all practice, these recurring obstacles become less scary.

It cannot be repeated too often that one way to learn is to look at what others do. Study the work of other botanical artists to evaluate how they deal with geometric forms, shadow, overlapping and foreshortening. Note how they have positioned the subject to give the clearest view of, for example, a foreshortened leaf. They may even have moved an individual leaf to enhance or simplify the shape, the shadow or the foreshortened image. Look at your own plant and make the same adjustments if necessary. You should not do anything to alter the character of the plant, but you are trying to make an exact representation of the plant in a way that is most pleasing to the eye.

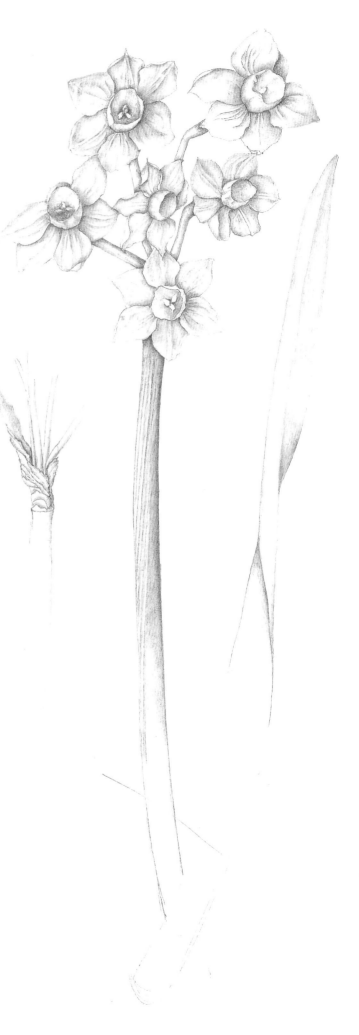

Right: This pencil drawing of a tazetta daffodil (*Narcissus* cultivar) shows flowers facing in different directions.

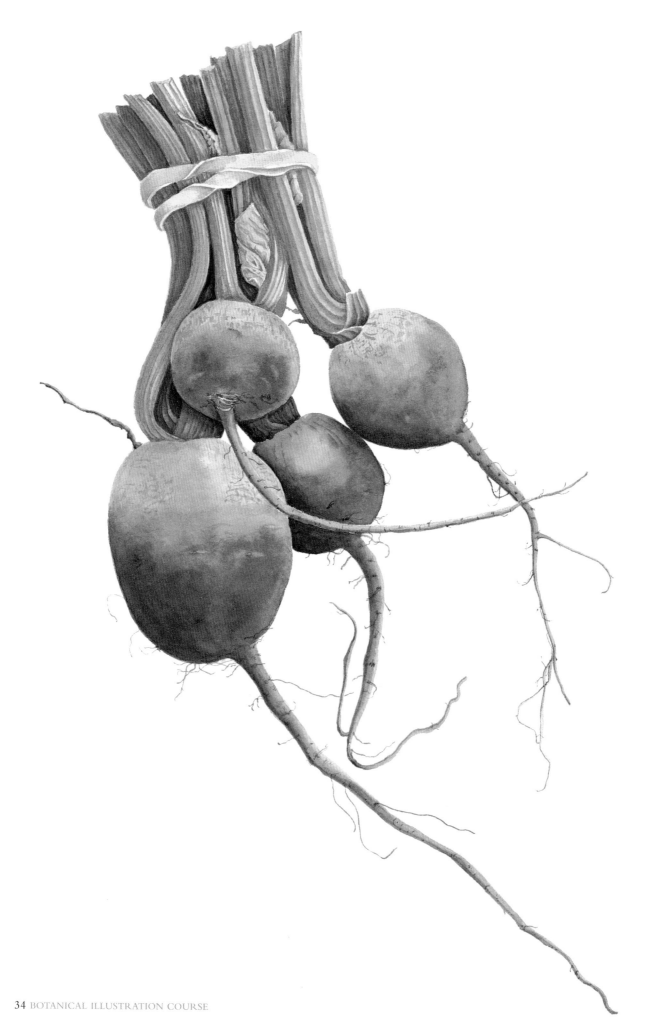

3. Roots

Roots spend most of their time underground, yet they are a vitally important part of the plant. This root study will teach you how to draw these unseen elements with an increased understanding of textures and patterns, making use of pencil work and the observational techniques you have learned so far.

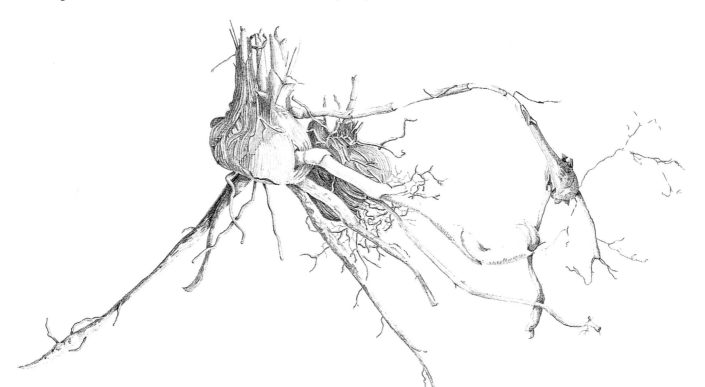

Drawing roots

There are many types of root. These include:

Bulb: A usually underground organ, consisting of a short disc-like stem bearing fleshy scale leaves and one or more buds, often enclosed in protective scales (onion, daffodil)

Corm: A swollen underground stem, somewhat bulb-like in appearance, but solid and not composed of fleshy scale leaves (cyclamen, gladiolus, montbretia)

Taproot: A strongly developed main root that grows downwards bearing lateral roots much smaller than itself (carrot, parsnip, dandelion)

Tuber: An underground stem or root, swollen with reserves of food (potato, dahlia)

Rhizome: A root-like stem, lying horizontally on or situated under the ground, bearing buds or shoots and adventitious roots (iris, ginger).

(Taken from *The Cambridge Illustrated Glossary of Botanical Terms*, Michael Hickey and Clive King, see Further Reading page 139)

Above and Left: Different textures – different treatments. Smooth and earthy for the beetroot (*Beta vulgaris*), busy and papery for the montbretia (*Crocosmia* x *crocosmiiflora*).

Select one of these root types to be your first specimen. Look hard and make notes on the appearance of your root. What is it like? Consider the scale and proportion. Assess how and where the tones fall on the root. Look at the texture, pattern detail and cast shadow. Decide which areas you will give more attention to and how. Include a bit of the stem (or leaf) and see how it relates to the root: how do they differ? Describe any differences you see.

Once you have finished your initial observation, think about how best to present your root. Turn it around. Draw it roughly in different positions and decide which one works best. Then, having decided on your composition, make a rough drawing to establish the structure of the specimen. Look for any inherent geometric forms and their placement. You can then either refine this first basic drawing or re-draw from it.

Aim to complete an accurate tonal representation, or at least part of one. Include dissected pieces or sections of root to explain it. Build up different textures and pattern by experimenting with the pencil techniques covered so far. Look for any foreshortening.

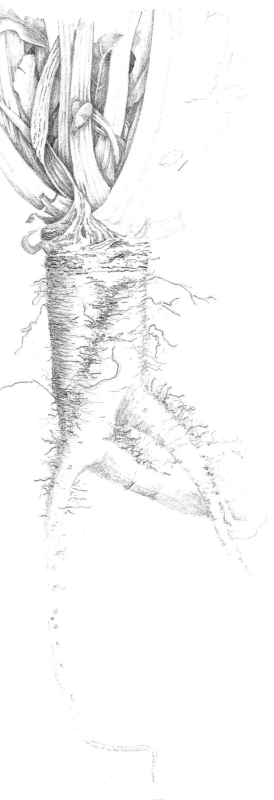

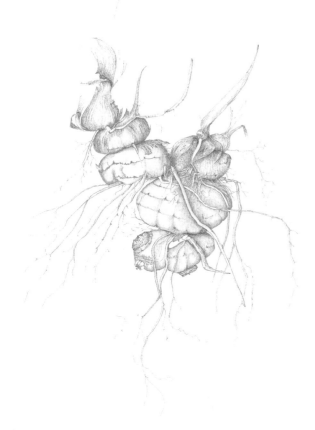

Above: The whiskery parsnip root (*Pastinaca sativa*) has been given a very different treatment from its own smooth, shiny stems and from the dry, papery corm of Montbretia (*Crocosmia* x *crocosmiiflora*), left.

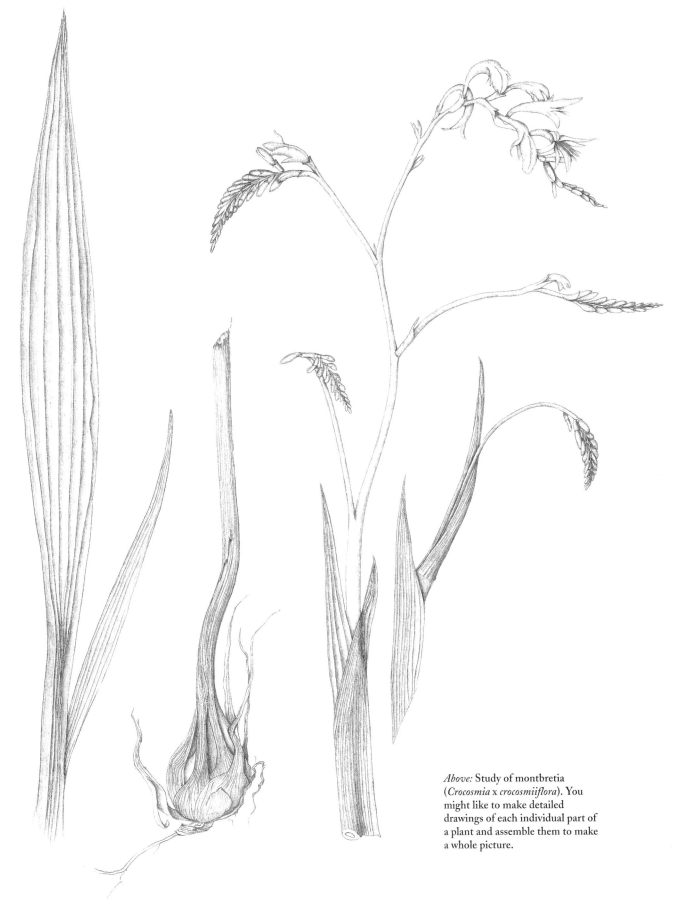

Above: Study of montbretia
(*Crocosmia* x *crocosmiiflora*). You
might like to make detailed
drawings of each individual part of
a plant and assemble them to make
a whole picture.

Roots and the plant

Once you are familiar with the various root types, you are ready to move on to a complete botanical drawing that shows how the root system relates to the rest of the plant. Start with a relatively simple root and plant structure such as a montbretia, and consider each part in detail.

Depending on what stage of its lifecycle you find it in, a montbretia consists variously of roots, stem, leaves, flower and seed head. You could depict the whole plant, perhaps focusing on the roots and using simple line drawing to show the rest of the plant. Or you could show selected parts more carefully within the same drawing, perhaps concentrating on tone and detail of the flower or seed head, depending on the focus you want your illustration to have.

Another way of working is to make more detailed drawings of each individual part that you can assemble to create a whole picture when all the parts have been completed. The pencil illustrations of montbretia on the previous page are a good example of this. You might choose to reproduce the whole root or the whole root plus a section; you could even draw the root alongside a section of the stem.

Notice the kind of texturing used on the montbretia root on page 37 compared with the beetroot on page 34. The drawing of the montbretia shows a broken, papery surface, while the beetroot (*Beta vulgaris*) is smooth and earthy. Now compare the texture of the beetroot with the sleek, linear leaf stalks above it. Try to indicate the different textures on your root by varying your pencil work. (For more information on texture see chapters 7 and 13.)

Although most roots are never normally 'on show', they can play a vital role in plant identification. However, many botanical illustrations include the roots not just for identification purposes but also for aesthetic reasons as part of the overall design.

After this exercise you will have a more complete idea of a whole plant and plenty of practice with your pencils. In the next chapter you will begin to introduce colour into your work.

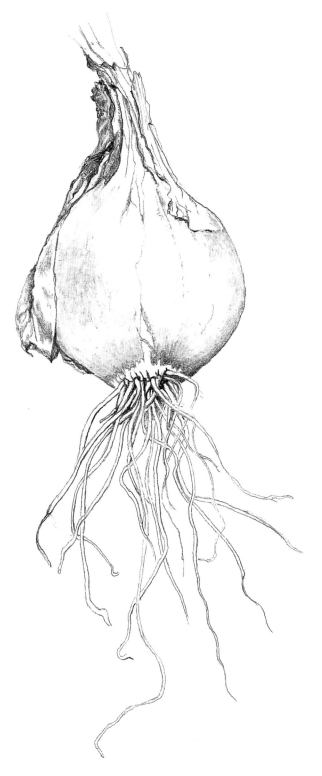

Above: These onion roots (*Allium cepa*) are strong and vital. Those in the foreground have been given greater definition than the others, particularly where they join the base of the bulb.

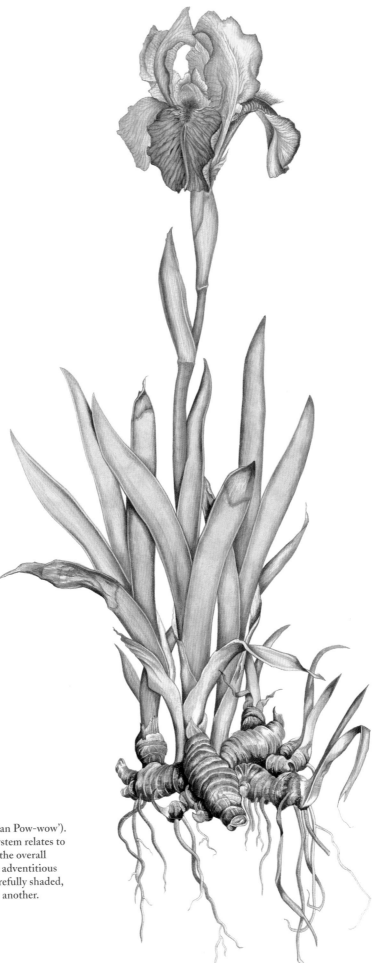

Right: Dwarf bearded iris (*Iris* 'Indian Pow-wow'). It is easy to see here how the root system relates to the rest of the plant and can add to the overall design of the picture. Note how the adventitious roots on the rhizomes have been carefully shaded, especially where one crosses behind another.

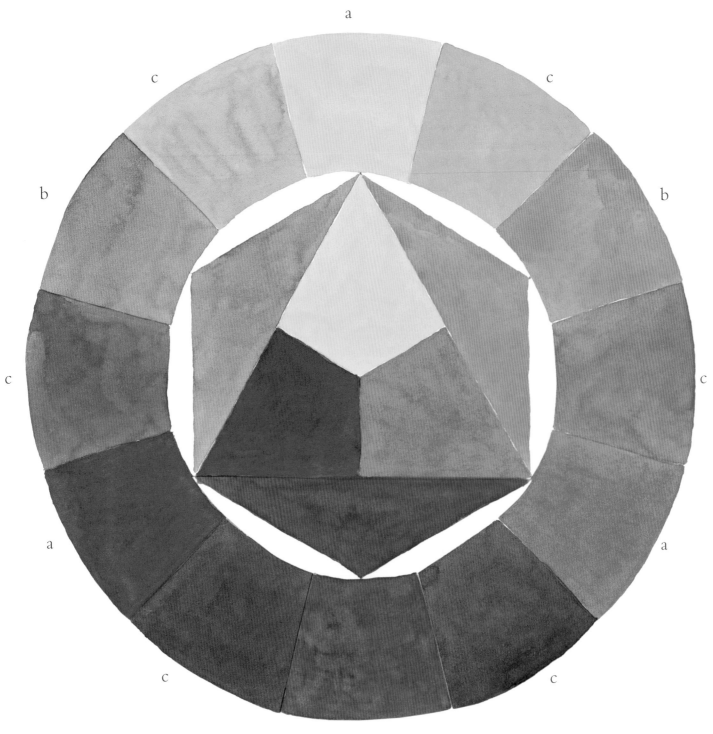

a

c c

b b

c c

a a

c c

b

4. An Introduction to Colour

A small minority of people have a natural colour sense and can mix any colour accurately. However, the majority of us have varying degrees of difficulty mixing the correct colour, so some knowledge of basic colour theory within the context of the paints available is important. It is possible to match any colour, but it is not usually due to a heaven-sent gift, rather by sheer hard work and years of experience.

There is no reason why you should not use paints straight from the tube or pan, but learning to mix your own colours gives you a greater understanding of the qualities of your paints, the different combinations needed to achieve different shades – and it's fun.

For these exercises you will require a cheap brush for mixing, a small watercolour pad for testing colour mixes (A5 Bockingford is fine), watercolour paints and a no. 6 brush.

The colour circle

Our colour circle is based on Johannes Itten's Bauhaus 12-hue colour circle. The sequence of the colours is that of the rainbow or natural spectrum. The 12 hues are evenly spaced, with the complementary colours diametrically opposite each other: in other words purple is diametrically opposite to yellow; blue to orange; and red to green (see below). If you think this is complicated, the artist Delacroix kept a 72-hue colour circle mounted on a wall in his studio, each colour labelled with possible combinations!

The primary colours, yellow, blue and red, are shown in the triangle in the centre of the colour circle and also at the corresponding position on the outer ring of the circle. There are many paint manufacturers who produce a variety of these primary colours, but few of them make pure primaries. A true primary colour is neither warm nor cool.

Left: Johannes Itten's Bauhaus 12-hue colour circle shows; a) the three primary colours, b) the three secondary colours and c) the six tertiary colours.

Right: See if you can tell the difference between warm and cool colours – and then check with the two colour circles shown on page 43.

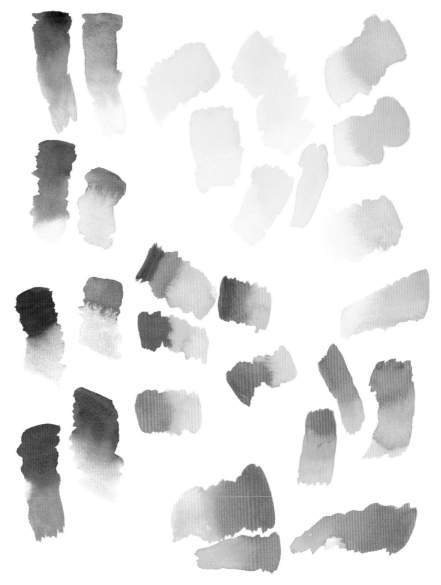

The secondary colours are orange, purple and green. They are shown alongside the inner triangle (green spanning its component colours, blue and yellow; orange spanning red and yellow, and purple spanning blue and red) and also in the corresponding position on the outer ring. It is easy to see, therefore, how secondary colours are created by mixing together two primaries.

Also on the outer circle, interspersed between the primary and secondary colours, are the colours made by mixing a secondary and one of its primaries. These are the tertiary colours. See how orange, when mixed with yellow, gives an orangey-yellow, but when mixed with its other component, red, gives an orangey-red. Likewise, purple mixed with red gives a plum colour, but mixed with blue becomes grey-blue. Green mixed with yellow gives lime green, but with blue yields aquamarine.

Incidentally, if you mix equal quantities of the three true primaries you should always get black. This is far superior to any bought black and lends itself to subtle variations in shade; for instance, you may need a browny-black in some instances, or a greeny-black in others.

Warm and cool colours

It is important for you to be able to differentiate between warm and cool colours, otherwise your mixing abilities could be severely compromised. For example, the wrong blue and the wrong red will not make purple; they will make brown. To help you to differentiate between warm and cool colours, two other colour circles are shown opposite, giving 12 warm hues and 12 cool hues.

Varying colours

There are several ways of varying colours: green may become more blue or yellow (turquoise or lime green); red may also become more orange or purple (crimson or vermilion); red may become more pink, maroon or cerise; blue may become more sky blue, indigo or slate.

Contrasting colours

There are several ways of contrasting colours. For example there is dark/light contrast (a bright red with a pale red), warm/cool contrast (orangey-yellow with a greeny-yellow) and complementary contrast; bright green looks more vivid in the presence of bright red than in the presence of blue. Throughout the years, painters have used complementary contrast to great effect; many great paintings resonate with blues and oranges, purples and yellows or reds and greens. These are all complementary contrasts.

Before setting out to create your sample strips in the next exercise, check your own paints against the charts and take some time to think about whether they are warm or cool. Here is how to check:

- Warm reds lean to orange or yellow
- Warm blues lean to purple or red
- Warm yellows lean to orange or red

- Cool reds lean to purple or blue
- Cool blues lean to green or yellow
- Cool yellows lean to green or blue

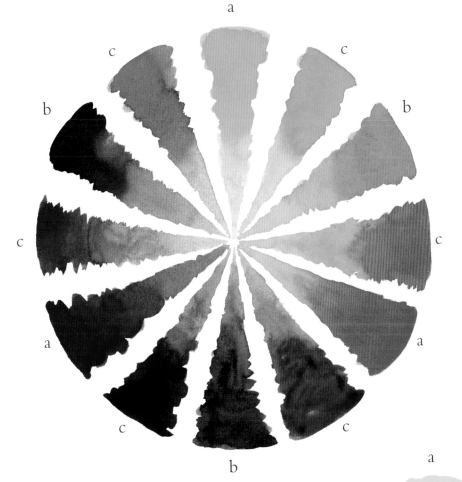

a

c　　　　　　c

b　　　　　　　b

c　　　　　　　　c

a　　　　　　　a

c　　　　　c

b

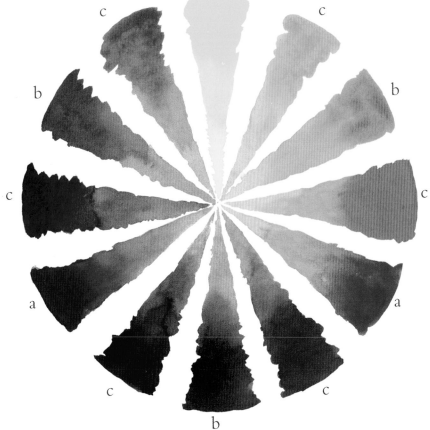

a

c　　　　　c

b　　　　　　　b

c　　　　　　　　c

a　　　　　　　a

c　　　　　c

b

Right: a) primary, b) secondary, c) tertiary. Warm colour circle (top) and cool colour circle (bottom). Note how the warm yellow and the warm blue make a dull green, whereas the cool yellow and cool blue make a vivid green.

1
2

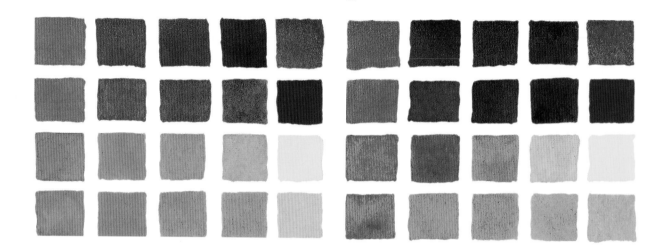

Colour sample strips exercises

Primary colours

The first exercise is to divide your primary colours into warms and cools for mixing purposes:

Warm reds, blues and yellows
Permanent red orange, scarlets, vermilions
Ultramarines
Gamboge or Indian yellow

Cool reds, blues and yellows
Crimsons, carmines, madders
Prussian or Paris blue, Winsor blue (green shade)
Lemons, pure yellow, transparent yellow

Think about why certain colours occur when mixed. For instance, if you are trying to mix a purple and use scarlet (warm, consisting of primary red plus yellow) and Prussian blue (cool, consisting of primary blue plus yellow), this will involve all three primaries and therefore make brown or grey. For a good purple, use a mixture of crimson (cool) and ultramarine (warm).

Above: 1) This shows what happens when you mix a warm red with cool and warm blues, cool and warm yellows.
2) Here a cool red is mixed with the same blues and yellows.

Take your cool colours first; paint a small square of lemon yellow. Add a tiny amount of Prussian blue and paint another square. Repeat, adding more and more blue until at the end it is all Prussian blue.

Now make a sample strip with alizarin crimson and Prussian blue, and then make one with the lemon yellow and alizarin.

Now repeat the same exercise using warm colours: Indian yellow, permanent red orange and ultramarine blue.

Complementary colours

Complementary colours are very important in the study of colour because they represent 'harmonious colour', that is to say, colour combinations that provide balance, harmony and symmetry of forces.

As we said earlier, a colour and its complementary colour (a complementary pair) are found diametrically opposite each other on a colour circle: in other words, yellow is diametrically opposite to purple; blue to orange; and red to green.

An equal mix of any complementary pair should yield black or grey. Therefore you will often find that the complementary colour is the one to use for shadow and shading on a subject.

Many different shades and tints can be obtained through mixing a pair of complementary colours and then diluting with water.

Now repeat the sample strip exercise, this time using complementary colours. While you are doing this, remember that the addition of red will tone down green and green will tone down red; purple will tone down yellow and yellow will tone down purple; orange will tone down blue and blue will tone down orange.

Below: Different greens achieved by mixing a cool yellow with 3) a cool blue and 4) a warm blue.

3

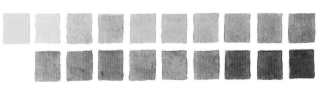

4

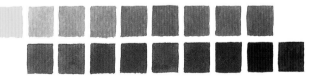

As with all your colour sample exercises, it is useful to jot down the colours you are using for future reference.

To start the exercise, paint a small square of orange. Add a tiny amount of blue (to make a browner orange) and paint another square. Add more blue to make an even browner orange and so on, until blue is reached.

Repeat with different red/yellow combinations (orange) with blues. Make oranges using different yellows and reds. Use each of these oranges to make sample strips, each with a different blue. Note the range of browns and purple-browns that are achieved.

Mixing the right green

As a botanical artist the colour you will use most, and which will give you the most grief, will probably be green. Spend some time experimenting with all the blues and yellows in your paint box to see how many variations of green you can mix.

Different yellows and blues make different greens. For example, a warm yellow (Indian) mixed with a warm blue (ultramarine) will result in a browny-olive green. It's fine if you actually need that particular green and have set out to mix it, not so good if it has simply been arrived at through lack of understanding.

As with the previous exercise, make colour strips using different combinations of the blues and yellows in your paint box. You will find these colour strips extremely useful when you need to choose a specific green for a painting.

Experiment with using green straight from the tube or pan and find out how to change or regulate it. Try a little crimson (cool) to sharpen your green. Try a little scarlet (warm) to mute your green. A little purple will darken it.

As with most things, time spent 'playing around with paint' is never wasted. You will learn the characteristics of your own paints, which mixes well with which, what to use for a particular green, or brown, or purple, and even which paints you hardly ever use and which therefore could give up their place in your paint box to a more useful colour.

Right: This exercise shows the huge variety of greens that can be mixed using different yellows and blues. The cool lemony yellow gives vivid greens, whereas the warm orangey yellows give quiet, subdued greens. Try the same exercise with the yellows and blues in your own paint box. Be sure to label each strip, as these samples will be useful when you need to mix a particular green.

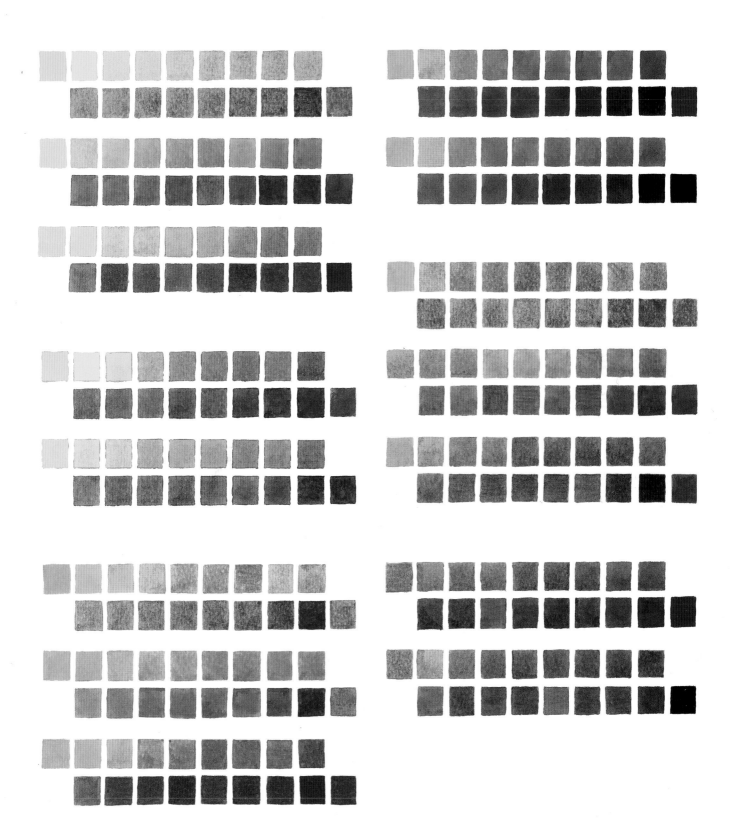

5. Starting to Paint

In this chapter you will continue to experiment with mixing colours, and will learn more about how you can apply and lift out paint. You will also be looking at different types of initial washes and their suitability to a subject.

Washes

The initial wash is very light and dilute. It determines the lightest areas of the painting. The lighter and more luminous the initial wash, the more tonal contrast can be incorporated into the finished work. When painting the initial wash it is important to keep the paint within the drawn lines. You should practise fluent lines and edges extensively. Try not to 'paste' the watercolour into the paper, as heavy painting will lead to a generally dull finish and the luminosity will be lost forever.

There are different types of initial washes, which can be varied according to the subject: flat wash, graded wash, blended wash (which are all wet-on-dry), wet-on-wet or superimposition.

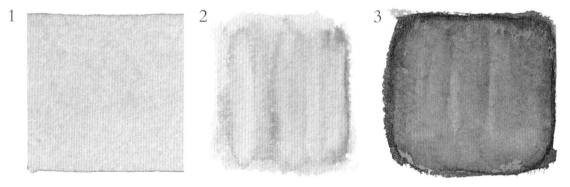

1) A flat wash is a pale wash painted straight on to dry paper. 2) This is a bad example of a flat wash − the brush strokes show, which indicates overworking. 3) This flat wash is too dark and has been overworked.

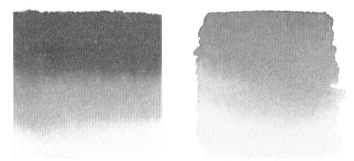

A graded wash is painted onto dry paper starting with a strong colour that becomes paler by progressively adding water to your brush until the initial colour has practically disappeared. Try to keep an even wash in the transition from dark to light.

A blended wash is painted straight on to dry paper, changing from one colour to another or blending one colour into another.

For a wet-on-wet wash, first wet the paper with clean water or a light wash, then drop in a stronger mixture of paint. This technique needs a lot of practice.

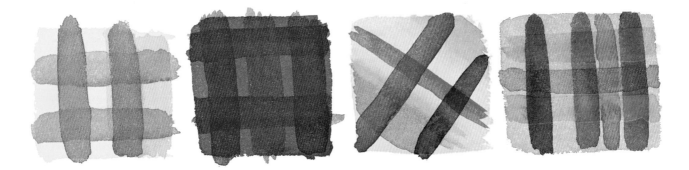

Superimposition uses layers of colour washes, on dry paper, either in the same or different shades. Like all the techniques used in botanical painting, wash skills will improve with patience, lots of practice and experience. You will find that one colour superimposed on another gives a far more vibrant effect than the same two colours mixed together in a single wash.

Do plenty of practising with the different washes. Think of different uses. Get into the habit of looking at specimens and working out the best method of painting them: consider whether a certain specimen would benefit from a wet-on-wet technique or a flat wet-on-dry wash.

Sometimes you might need to lift off colour from a painting after it has dried. Use a damp brush and blot carefully with a tissue.

Right: Paint has been lifted off with a damp brush. This can be useful when tackling lowlights (see chapter 7).

If you need to re-paint these areas, make sure they are perfectly dry before you begin. Overworking an area of wet paint can destroy the surface of the paper and also makes subsequent layers of paint lose their freshness.

Handling watercolour exercise

The main purpose of this exercise is to familiarize yourself with watercolour and its behaviour. Don't be afraid of it. Just remember that in time you will control it. Be patient. Try not to rush. You are not in a race.

Using your watercolour book or pad, your first step is to draw a series of increasingly complex shapes (see opposite) and practise filling them in with pale, flat, even washes. If using yellow, take particular care to paint inside the pencil outline, as it is particularly difficult to erase pencil from underneath yellow.

Experiment with wetting the paper first and then dropping colour into the wet shape, wet-on-wet. Don't mix colour on the paper. Continue practising various ways of washing-in your shapes until you begin to get the feel of paint, water, quantities, drying times and brush handling. Feel free to make as many mistakes as you like! There is so much to be learned from what goes wrong.

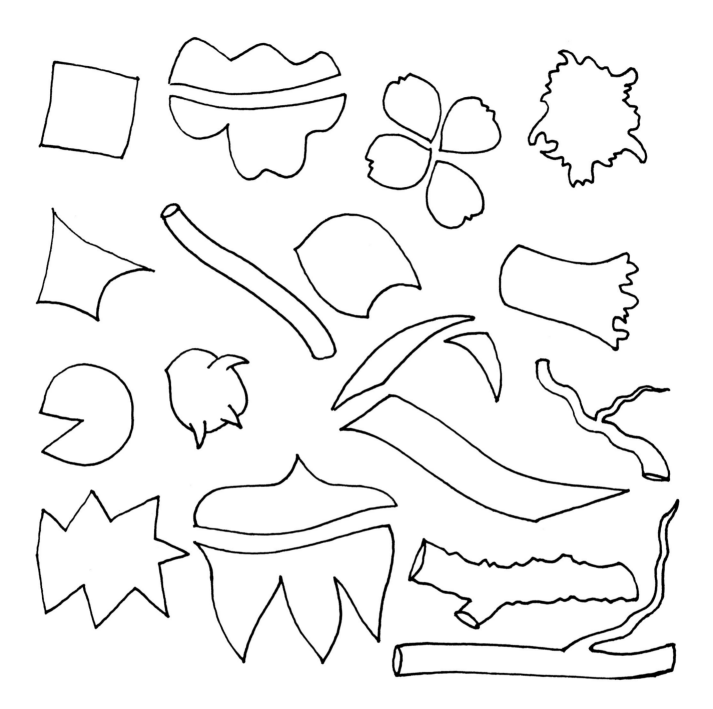

Above: To familiarize yourself with watercolour and its behaviour, draw some increasingly complex shapes like those above (all of which can be found in plants) and practise filling them in with a variety of washes.

This wet-into-wet technique can be a good counteraction to any inherent heavy-handedness in watercolour. Dropping colour onto wet paper can help you to avoid pushing the paint into the paper. It can mean the difference between a clear, sparkling painting and a dry, overworked one.

The next part of the exercise is to draw out eight squares about 2.5 x 2.5cm (1 x 1in). Mix up a large quantity of a light wash. Paint all the squares with the wash. Let them dry, and then paint all except the first with a second coat. Let them dry, then paint all but the first two with another coat. Repeat until the final square has eight coats of the same wash. You should have a build-up of coats ranging from one to eight layers. Notice the differences between them.

You can repeat this exercise using different colours if you wish.

Controlling the paint on the paper is not something that you will learn overnight. With practice you will discover how wet the paper needs to be, how much paint to load on your brush and how to blend gradations of paint so that they merge evenly. Keep all your early efforts – you will be amazed at how you improve.

Right: Examples of washes gone wrong:
1) Wet-into-wet where the water has started to dry before the colour was added, giving this measly effect.
2) A flat wet-on-dry wash. The edges have been painted first and have started to dry, leaving a heavy border.
3) A flat wet-on-dry wash where too much water has been used, giving a root-like effect.
4) Similar to 3, but extra paint has been added to the centre.
5 & 6) Wet-into-wet – but too wet.
7) A graded wash – too much water was used in the grading process, giving the tree-root effect.
8) Wet-into-wet, similar to 1, where colour has been added when the initial wash was too dry.

1

2

3

4

5

6

7

8

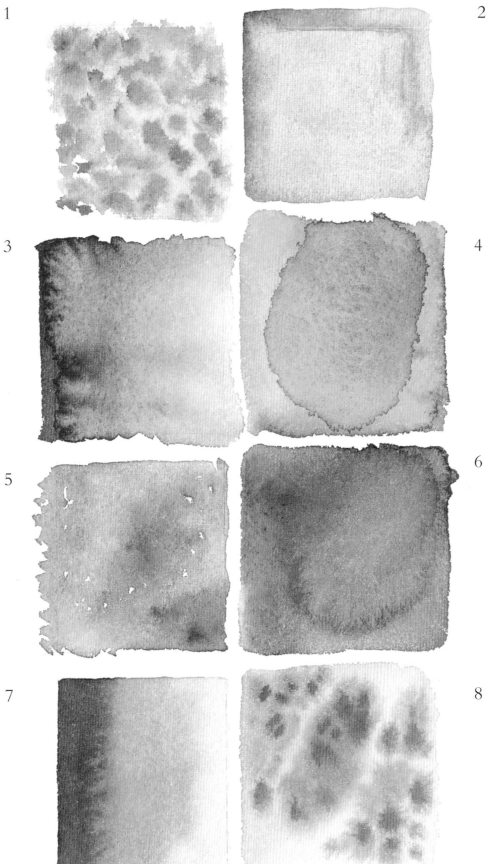

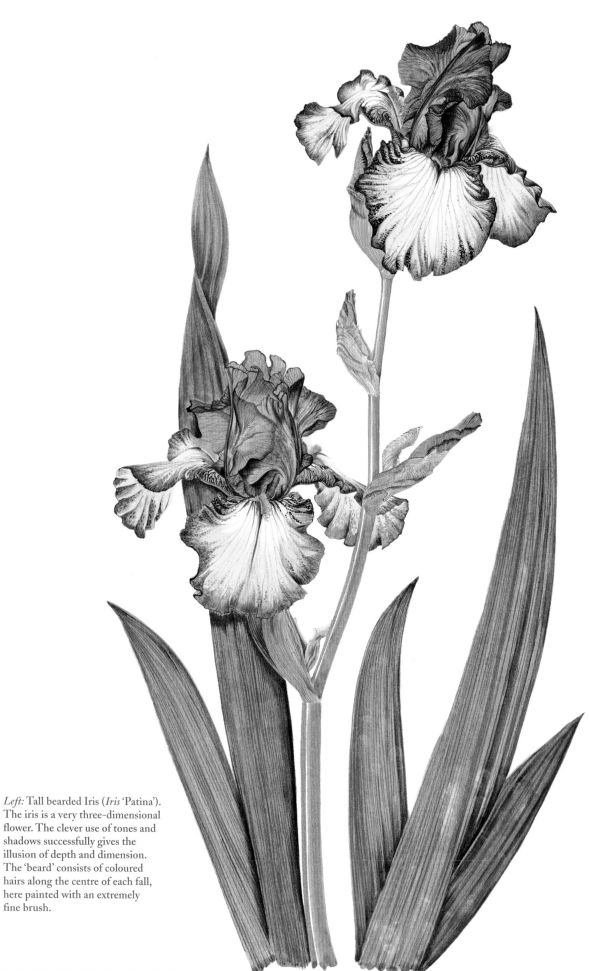

Left: Tall bearded Iris (*Iris* 'Patina').
The iris is a very three-dimensional
flower. The clever use of tones and
shadows successfully gives the
illusion of depth and dimension.
The 'beard' consists of coloured
hairs along the centre of each fall,
here painted with an extremely
fine brush.

6. Tones and Shadows

When successfully executed, tonal gradation, or blended tone, will produce the illusion of solid three-dimensional form on a two-dimensional surface. If tones and shadows are done well, you will achieve a living representation with depth and a natural appearance. This requires plenty of practice and patience. Make sure you are constantly aware of your light source and its effect on your painting.

Tonal gradation

In this chapter you will explore techniques of blending both lighter and darker tones. In lighter tones the technique can be applied by blending an area of strong paint into the initial wash. With subsequent darker tones, however, care must be taken not to disturb undercoats and it is preferable to stipple (also known as hatching). This involves applying tiny amounts of paint with a very small brush and can be used in conjunction with or instead of washes.

Stippling, or hatching, dates back to 17th-century botanical painting. It involves the careful use of fine lines – and in some cases, dots – laid parallel to one another, creating a smooth and even tonal change from light to intense dark.

If you try to stipple with a brush that is too dry, the result will be scratchy and rough. This kind of effect may be appropriate if you are conveying a special texture or pattern, but it does not work for the smooth transitional tonal change that is required to create form.

With the various stippling techniques, the amount used depends entirely on individual style and preference: a very detailed painter might use more small brushwork than a painter who favours a looser, more fluid style.

When practising these techniques, two very important points must be borne in mind. First, take care that the gradation of paint is smooth and even, without leaving brush marks or dry, scraped lines. Second, make sure that your edges are sharp and clearly demarcated. A fuzzy botanical painting does not work. The contrast of the sharp edge and the graded paint blended away from that edge is what gives the 'rolling around' effect necessary for naturalistic, three-dimensional results.

Right: 1) An area of strong paint has been blended into the initial pale wash. 2) The shading on the right shows stippling on a dark background. The longer strip illustrates what happens when you try to blend paint with a damp brush on a dark ground – some of the initial wash has lifted off. 3) Tonal gradation successfully shown in pencil work.

1

2

3

Study of tonal gradation

To help your own practice, look at work by other painters and record evidence of tonal gradation – how it has been used, in which areas and where it has been successful. You will soon begin to recognize how other artists have painted their pictures, and will learn how to apply this knowledge to your own paintings (See Further Reading, page 139).

Then go on to study three-dimensional specimens and look for areas where you would use tonal grading. Consider which technique would be most suited to your specimens and then practise working on small areas to see if it is appropriate.

Try using different amounts of paint, wetter or drier, different sized brushes and different techniques to see what results you achieve. As always, do not be afraid of making mistakes, since they are often the best of teachers.

As with the other basic techniques, there is nothing you cannot achieve in your representation of tones and shadows by continuous practice. The more times you repeat the techniques, the more familiar they become and the easier they get. And although watercolour is often seen as difficult and unmanageable, the process of botanical watercolour painting is such an organized and cerebral art-form that competent fulfilment is only a matter of thought, choice and practice, in that order.

Right and Far Right: The treatment of tonal gradation is much the same whether you are using black and white or colour. It is shown particularly well in this seedhead of a bottlebrush (*Callistemon* spp.), and in the gills of the toadstool on the opposite page.

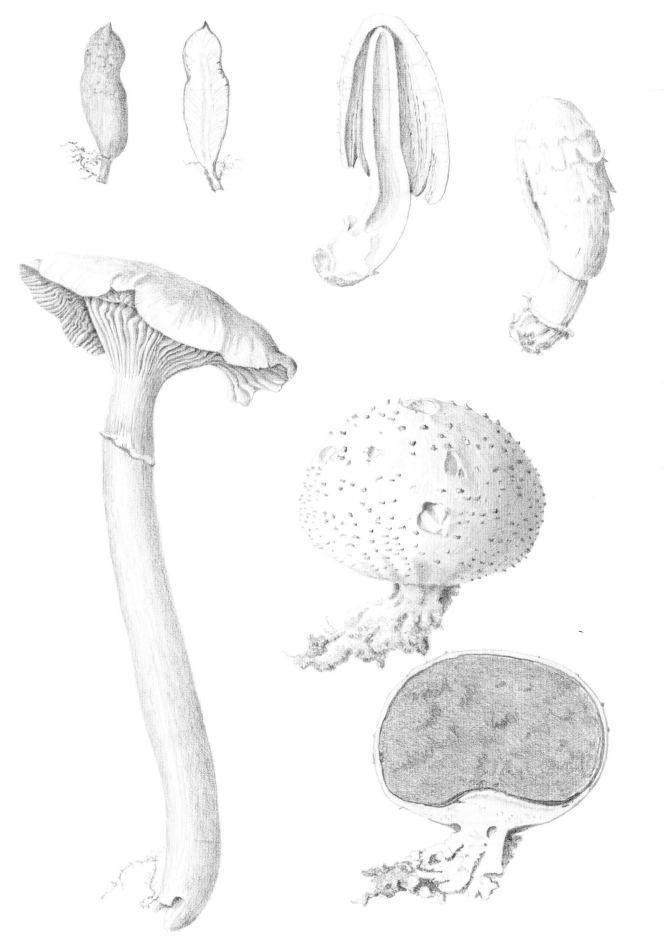

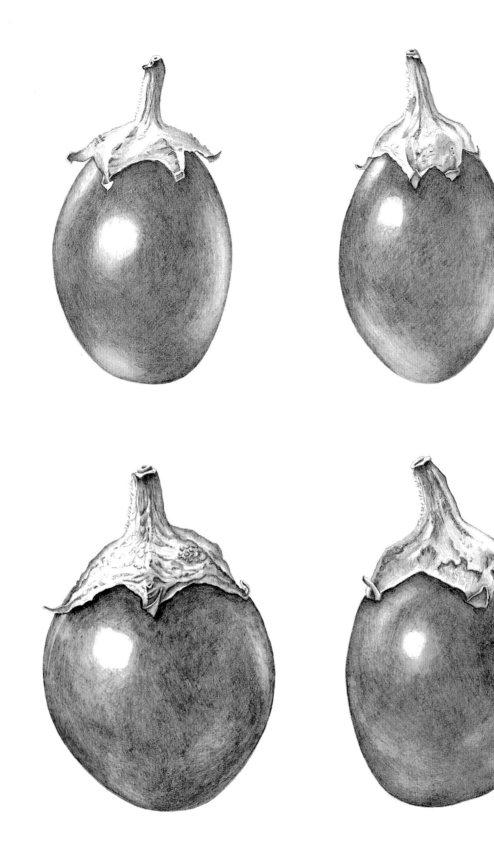

Above and Right: More studies of tonal gradation in black and white. Notice how different surface textures have been described by clever use of pencil.

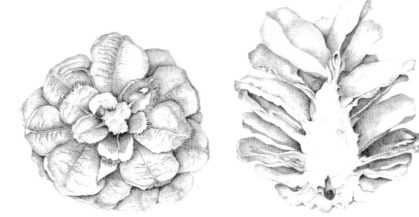

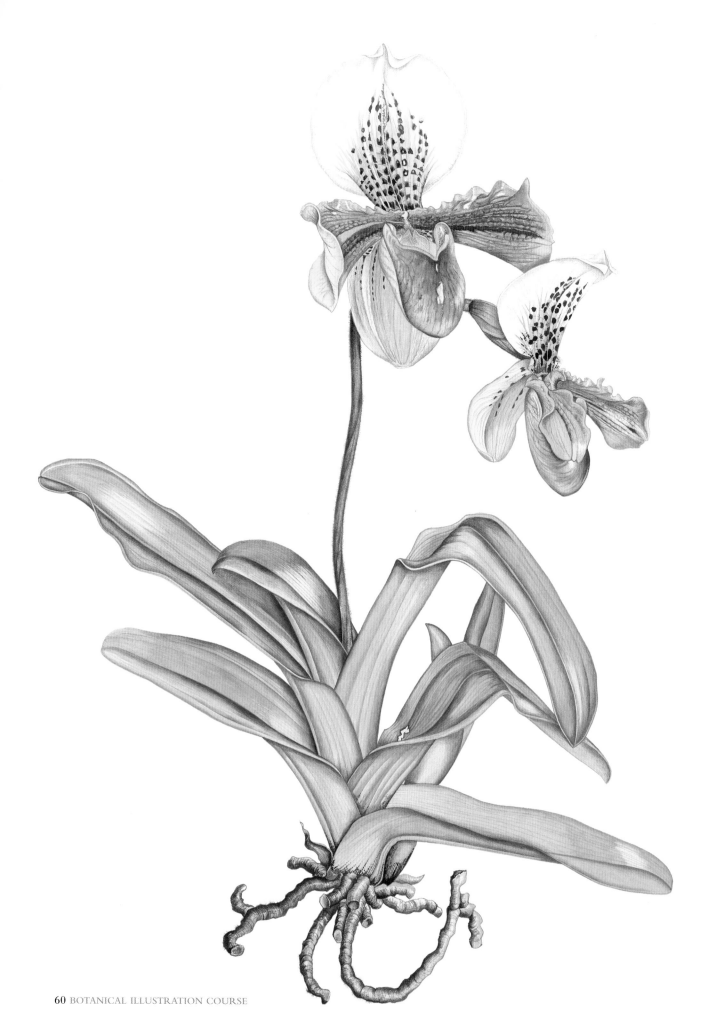

7. Detail, highlights and 'tweaking'

The detail in botanical illustration is the careful finishing that binds all the elements of a picture together, whether in pencil or in paint. See chapter 13 for examples of more texture. It can be extensive or minimal, depending on personal style and requirement; but however minimal your style, detail is necessary to complete your painting.

It can be difficult to know when a watercolour painting is complete, so you need to proceed with the utmost caution when putting the finishing touches to all areas. Remember to take several breaks and contemplate the 'finishedness' of your work – be intrepid!

Applied haphazardly or without thought, detail can easily ruin a painting. You must give careful consideration to how much detail to add, and it is very important to know when to stop.

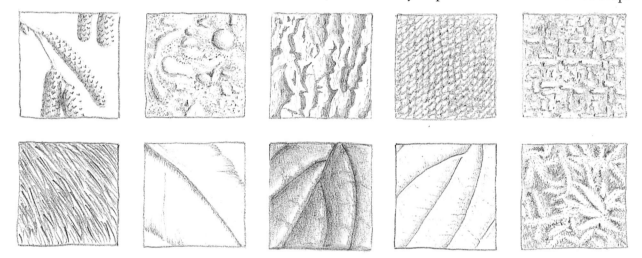

What is detail?

Detail can be many things – surface pattern, texture, fine hairs, addition of white, painting between stamens, deepening some areas of tone, redefining and sharpening up edges (this is what we call 'tweaking').

Elements that fall into the category of detail are fine lines such as veins; using a blended tone to tidy up rough edges; painting fine hairs and roots; painting long blended lines; and dampening some fine petal veins like those found in irises and camellias.

White watercolour paint has its uses in applying detail. Titanium white is an opaque watercolour with good overall covering capacity. Chinese white is not as opaque and often lets the under-colours of previous layers show through.

Left: The eye is first drawn to the intricate details on the blooms of the Slipper Orchid (*Paphiopedilum* cultivar) before travelling on to examine the leaves and roots.

Above: Different use of pencil for different textures – catkins, concrete, bark, tapestry, woven fabric, fur, feather, leaf (top), leaf (underside) and moss.

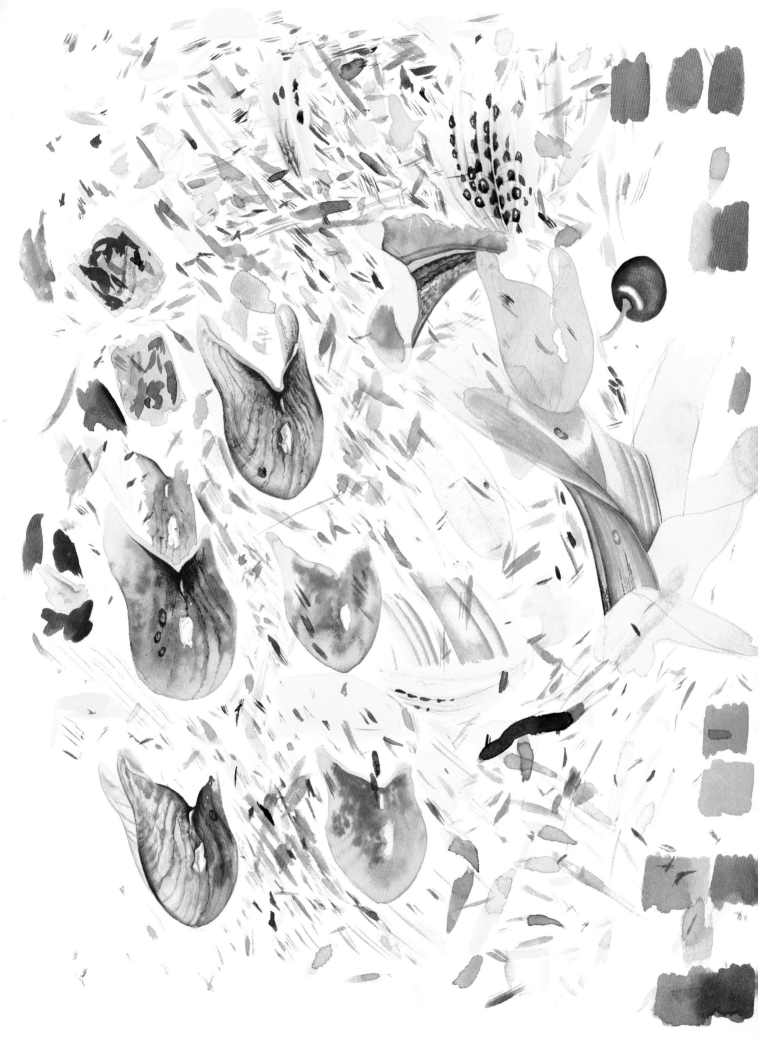

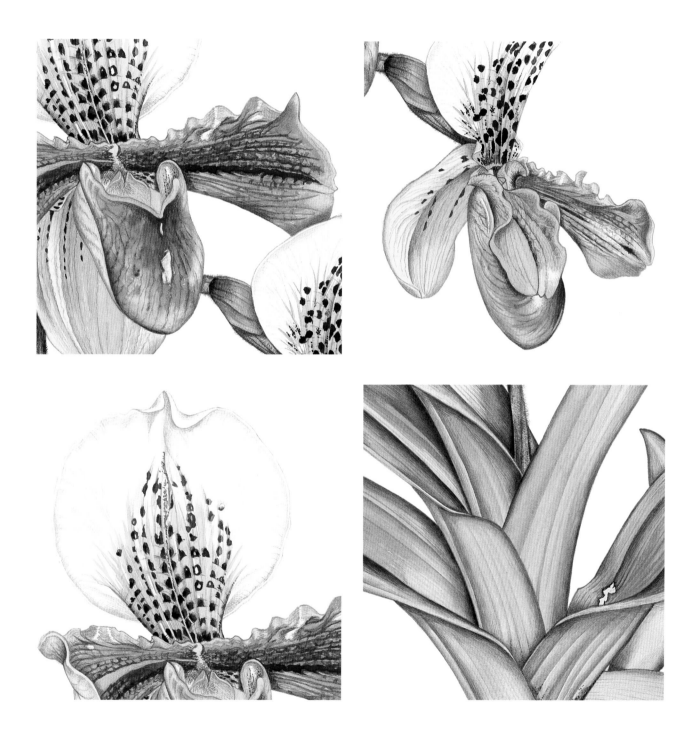

Left: Worksheet for the Slipper Orchid (*paphiopedilum* cultivar) showing practice washes for the lower petal (or lip), a twisted leaf and the various colours used. Somehow a cherry has crept in too!

Above: Detail of the Slipper Orchid (*paphiopedilum* cultivar), shown in full on page 60.

The use of white should always be carefully considered and used sparingly as too much can be incongruous, dull the overall watercolour effect or look downright clumsy.

Some watercolour artists choose not to use white at all, as they believe that it goes against the very nature of pure watercolour painting. This is an individual choice, but many believe that carried out sensitively and in context, the end result, if good, can justify the means.

Bloom

The bloom on fruit such as a grape or plum and the velvety texture of pansies (*Viola* spp.), Sweet Williams (*Dianthus borbatus*) and other flowers can all be treated in much the same way. Following the principle of watercolour painting, make your initial wash the palest colour possible or leave white.

Follow this with several washes of transparent colours, allowing the paper to dry completely between layers. Blend the edges of each wash where necessary to avoid the formation of hard lines.

Chinese white may be used for painting a white bloom or film of white on pale leaf undersides, berries, and fruits such as grapes, plums and damsons, but in the hands of an inexperienced artist the effect will be inferior to the method described above.

Both titanium white and Chinese white can be mixed with other colours to paint veins on top of darker leaves, or fine hairs on stems.

Your brush will need a good wash in hot soapy water after using white paint.

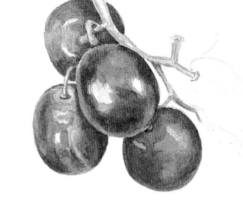

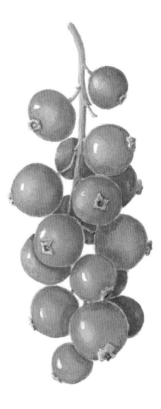

Right: Bloom on a grape and shine on a redcurrant can be portrayed either by leaving the white paper to show through or by careful use of white paint. White paint can give a heavy, dull look if not handled sensitively, so take care if this is your chosen method. We suggest you try both methods to see which you prefer.

Highlights

To represent the sheen on a leaf or fruit can be daunting. Look carefully at the colour of the highlight. It might be white, or in the case of a camellia leaf it might appear as a very pale blue. First outline the areas of highlight very lightly in pencil and leave untouched when painting the rest of the leaf, though blending the edges. Finally give the highlighted area a light wash of the required colour.

If the highlighted area appears more as a dull sheen (a lowlight), a popular way of showing it is simply to lift off paint with a damp brush. You can do this while the paint is damp, but it is easier to wait until the area is completely dry before attempting it, otherwise you could end up with a halo effect rather than blended edges. Practise this on a sheet of rough paper first, to establish whether the paints you are using are low-staining colours and will indeed lift off.

Right: Examples of highlights and lowlights (top to bottom): Camellia, two generic leaves with petioles, pennywort (*Umbilicus rupestris*).

The strawberry

The purpose of this exercise is to show you how highlights and other effects can bring a botanical painting to life. In this instance, we will use a strawberry. It is a good idea to use a 'third arm' apparatus to position the fruit. Make sure that it is well lit in order to record all the changes of light falling slightly differently around each pip and subtle changes in moulding. This will help to prevent your work from becoming repetitive, tired and formulaic.

Take a No. 2 short-haired brush with a fine point. Start with the seeds and work across the fruit. Build up layers from light to dark as you go along, leaving out highlights around the individual seeds. It is a good idea to use many different shades of one colour within a painting. When painting the flesh, try using several reds, pinks and oranges in varying strengths to build up a multi-textured and three-dimensional surface on the strawberry. Combine overlaying washes with blended tones. Hard lines should be merged and softened with a damp brush.

Above: The skin of the strawberry (*Fragaria* x *ananassa*) is shown by different shades of red, orange and pink. Note the highlights around individual seeds.

How much detail?

When considering detail, the big question has to be 'how much?' Knowing when to stop, especially in watercolour, is not an exact science and many people adhere to the maxim 'when in doubt, leave it out'. With botanical illustration, some questions must be asked, however. These questions range from 'can it be left out?' and 'is it necessary to the plant?' to 'will it overemphasize?' Remember, though, that if your interest in botanical illustration is to aid accurate identification by botanists and others, it may be that the fine detail is what differentiates one plant from another in the same genus.

When considering your own paintings, set up a dialogue with yourself and ask questions such as these. You will find that this is also a confidence-building exercise as you begin to learn to trust your own instincts as to what looks good, has style, fulfils the criteria set by the brief and displays the required elements.

Once again you will find it useful to look at paintings by various artists. Ask yourself how they dealt with highlights, where they used detail and how much they employed. Make notes about the types of finishing used in relation to the personal style of a chosen artist and how one compares with another. You will find it helpful to study detail with a magnifying glass, all the time keeping in mind the evolutionary process involved in reaching this final stage.

The amount of detail you decide to use can be sparing or infinite, but the secret of good detail application is in knowing when to stop. Overworking will kill any painting stone dead and watercolour is not easy to remove, because all previous layers become subject to disturbance.

Below and Right: It is helpful to use a magnifying glass when looking at the detail in other artists' work. Here we have made life easy for you by enlarging sections of two of the illustrations in the book (page 108 and 129) so that you can see the brushwork and treatment of delicate areas.

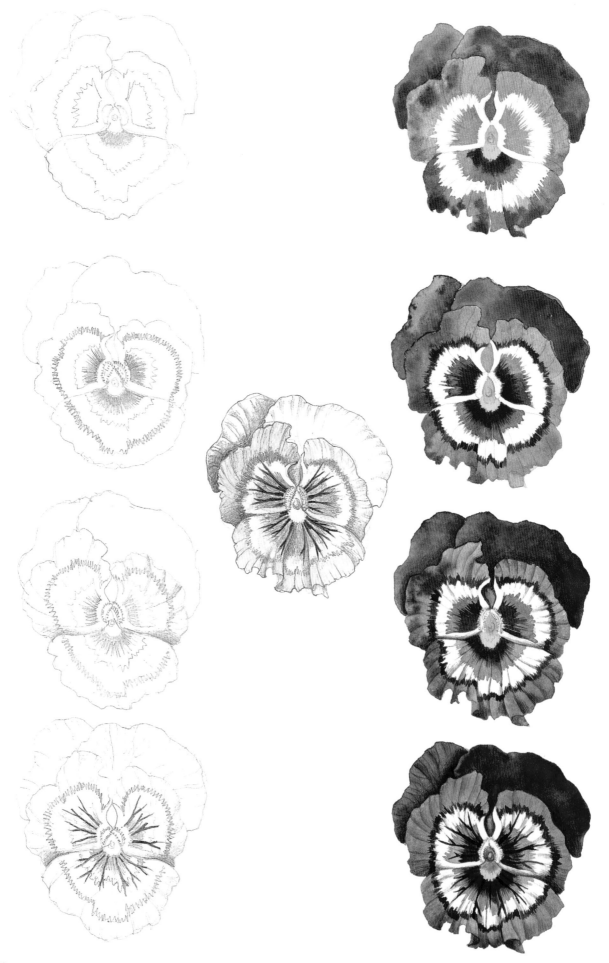

8. Putting the Stages Together

Now is the time to begin to put together what you have learned so far. The specimens you will need to find for your practical work are an ivy leaf, which is relatively simple to paint, and a daffodil or narcissus, which always presents problems to the botanical artist. You will need to put your observational skills into practice. Working in your sketchbook will be helpful here for taking notes and making drawings. Use your small watercolour book to test various techniques and colours.

Do not worry if the techniques you use do not work as well as you would wish. The most important part of this exercise is improving your understanding and then practising the order of application.

The ivy leaf

The ivy leaf lends itself to all painting stages. Because it is flat and has a relatively simple overall shape it can be drawn quickly and efficiently, without added problems like foreshortening, complex forms, complicated vein patterning and heavy or multiple texturing.

Before you embark on the final painting, compose and complete a worksheet based on the ivy leaf. Include the following elements on your worksheet: your observations and planning of the layout, a section of colour trials and a detailed drawing in pencil showing tones. Think about what kind of washes to use and how to deal with veins. Record your thoughts on your worksheet. Your finished leaf can be on a separate sheet or form part of the overall worksheet.

When you come to attempting your leaf you should first draw it very lightly in pencil. Then apply an initial wash as appropriate – i.e. wet-on-wet, wet-on-dry, blended. Consider highlights and lowlights and how you will deal with them before laying your wash. Make sure the wash is of good quality and not too dry.

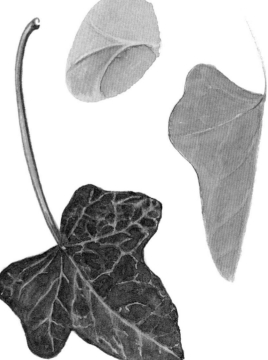

You may prefer to leave out the veins from the start, painting each section separately and leaving them as the demarcation lines; or you may choose to lift them out with a damp brush later, as with lowlights. This can be done either when the paint is damp or after it has dried, having first checked the staining qualities of the particular colour being used. Some paints stain the paper and therefore cannot be lifted completely. Try the paints out on a scrap of similar paper. The more tests you do, the more familiar both materials and techniques become.

Left: Putting the stages together in pencil and in paint. Study this page and note the additions at each stage.

Right: Ivy (*Hedera helix*) has a relatively simple leaf that is a good subject for your first practical worksheet.

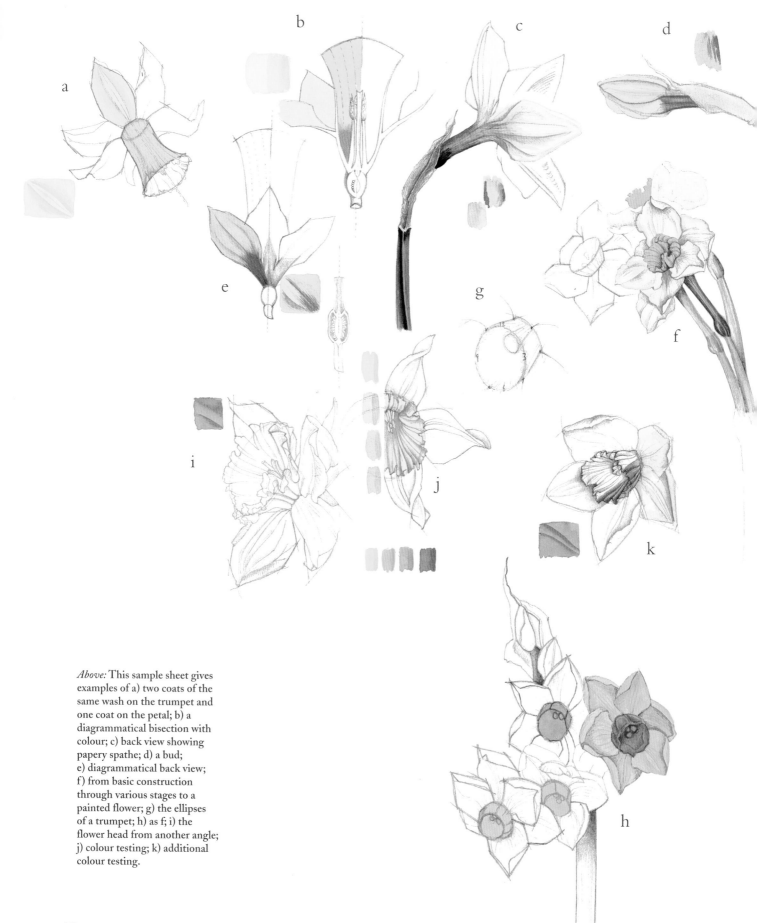

Above: This sample sheet gives examples of a) two coats of the same wash on the trumpet and one coat on the petal; b) a diagrammatical bisection with colour; c) back view showing papery spathe; d) a bud; e) diagrammatical back view; f) from basic construction through various stages to a painted flower; g) the ellipses of a trumpet; h) as f; i) the flower head from another angle; j) colour testing; k) additional colour testing.

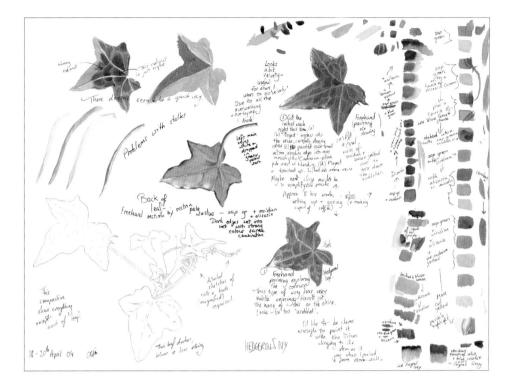

Above: A very good example of sketchbook practice based on an ivy leaf. This student has made extensive notes on everything that she has done.

Make sure when applying the paint that each section has even treatment. This means making sure that each section is painted evenly, if you are painting a bit at a time. Watch out for a fragmented, 'stained glass' character in your leaf. This fragmentation may or may not occur, depending on the type of painting you favour: if small, dry brush strokes are used overall, the risk of uneven washes will be eliminated.

Detail should be applied in areas such as darkening around the veins and stems, and tidying rough edges.

Daffodils

Before drawing your daffodil, refer back to the section on foreshortening in chapter 2.

Yellow flowers present particular problems. It can be difficult to know how to shade or show tone when painting them. Simply using darker yellow for the shaded areas does not necessarily work – a stronger shadow colour is usually needed. This could be a grey or even a light purple; or, if it is a technique you enjoy, you could put in the tones with a graphite pencil (see chapter 12, Watercolour Over Pencil). The generally accepted rule of thumb is to use the complementary colour to produce shade or tone, because a colour and its complementary mixed together give black or grey.

Grey shades, however, do not always sit well on top of yellow paint. They can move or lift the yellow, which results in a dirty mess that cannot be retrieved or fixed. Very light yellows or creams usually take grey reasonably happily, but it is best to proceed with great trepidation when dealing with any yellow flowers. The working sheet opposite shows examples of different yellow paint strengths with different grey shades, some painted under the yellow, some on top. Greys were mixed using variations of the primary reds, yellows and blues. Mixing from primaries offers a great range of greys, each appropriate to a given specimen. Also, practising using primaries greatly enhances your colour-mixing ability.

Watercolour over pencil can be a good way of tackling yellow flowers. The soft pearly tones of very hard pencils (5H, 6H, 7H) shaded underneath paint can be as effective as paint and easier to apply. Look back to chapter 1 on pencil drawing for a reminder of the tones and control you achieved using pencil.

Choose your specimen from the narcissus family. Before you start to work, look at daffodil paintings by several different artists, comparing and contrasting their different working methods, techniques, compositions and results. Start with some observational drawing on your worksheet followed by colour mixing and application, paying particular attention to painting complex areas like the frilly end of the daffodil trumpet (see page 70).

Practise again all the techniques you have learned to date, as you did with the ivy leaf. Remember to use the 'building up' process or systematic approach. You also need to look at the application of layers of different yellows and decide on what kind of yellow. The yellows used for daffodils can often be too harsh, too acid, too dirty, too deep or too pale. Experiment with which yellow to use, and how much, and where to place tone, as too much shading can be at best misleading and at worst can obliterate most or all of the yellow. Remember that yellow is the lightest colour in the spectrum. It is also the easiest colour to dull. The wrong tonal shades can all too easily render yellow lacklustre and dingy. The illustration on page 70 shows some tricky colour mixes, like pale yellows as well as deeper, warm and cold yellows.

You will now have done some washes and made decisions about the treatment of veins. You will have learned quite a lot about greens and yellows, what mixtures of paint to use and how to suggest realistic shading and shadows. How did you shade the ivy leaf, for instance? Did you use a darker (bluer) green? Or did you try green's complementary colour, red? Did you shade your daffodil with grey, or purple, or perhaps with a graphite pencil? It is only by trying all these combinations that you will discover which best suits you and your own subject matter.

Right: The problem with yellow: Shading on each strip, from left to right: purple-grey; neutral grey; green-grey; brown-grey; blue-grey. a) Single layer wash (top) and double layer wash (lower) wet-on-dry, warm yellow. Shading painted over wash layers. b) Single layer wash (top) and double layer wash (lower) wet-on-dry cool yellow. Shading painted over wash layers. c) Single layer wash (top) and double layer wash (lower) wet-on-dry warm yellow. Shading painted under wash layers. d) Single layer wash (top) and double layer wash (lower) wet-on-dry cool yellow. Shading painted under wash layers. e) Watercolour over pencil. Blended wash of mid-warm yellow (top) and mid-cool yellow (lower). Pencil shading from dark to light.

a

b

c

d

e

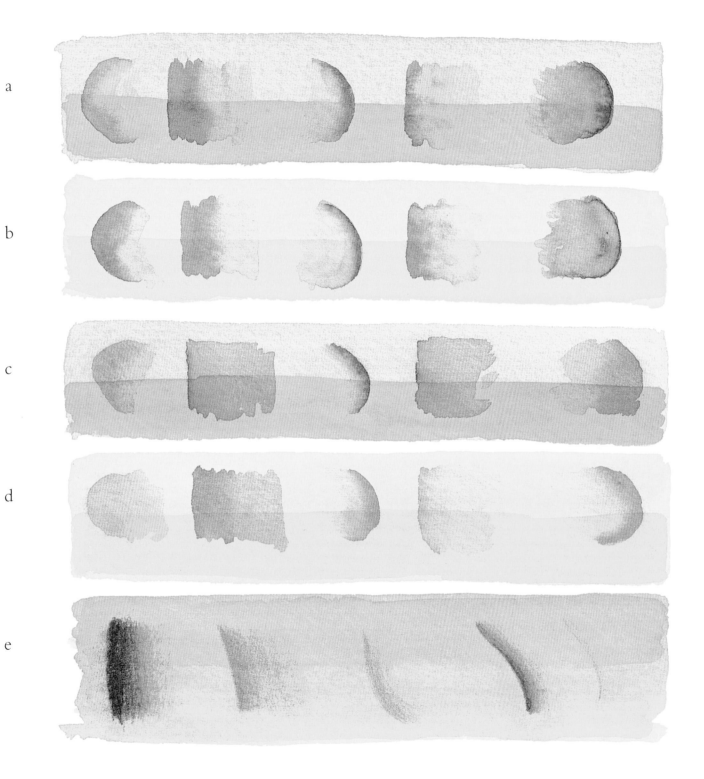

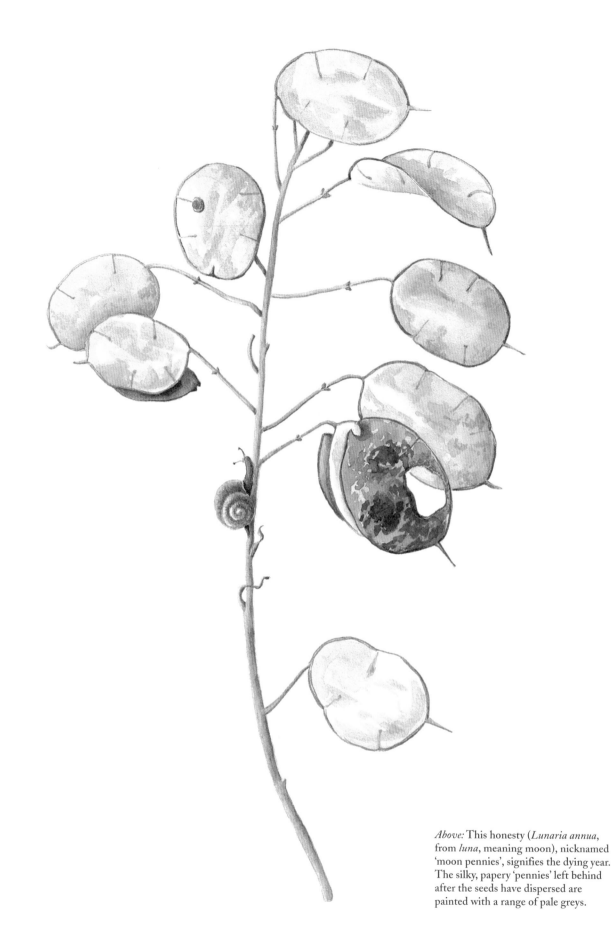

Above: This honesty (*Lunaria annua*, from *luna*, meaning moon), nicknamed 'moon pennies', signifies the dying year. The silky, papery 'pennies' left behind after the seeds have dispersed are painted with a range of pale greys.

9. Seasonal Colour, Autumn Fare and the Apple Revisited

The colour exercises in this chapter are designed to increase your understanding of mixing and matching colours and shades and to help you evaluate which ones relate to each of the four seasons. You will be painting colour blocks to represent the four seasons and looking in more detail at the colours and shapes of autumn, including revisiting the apple you drew in chapter 1.

Autumn colour includes many oranges, ochres, browns and cool reds. At this time of year an interesting phenomenon occurs with the complementaries orange and blue. As the leaves turn orange, gold and brown, the bright blues of autumn skies resonate with the landscape. Blue road signs against orange trees, a blue house set against orange woodland: these two colours 'complement' each other.

Understanding which colours complement each other, and how they affect each other's performance, will help you to bring vibrancy to your own paintings.

Seasonal colour blocks

Arrange a block of fifty 2.5cm (1in) squares close together, with five squares across and ten squares down. Repeat so that you have four rectangular blocks (see overleaf). Each block represents a season and each square is painted with one of the colours that you consider appropriate to the particular season.

This exercise is not as easy as it might at first appear. You will find it helps you to develop several skills. First, you will be able to discover and illustrate the differences between seasonal colour changes, and you will be better able to select and mix specific colours. You will find yourself picking up on previous painting exercises, such as laying a flat, even wash, carefully painting shapes and keeping paint within drawn lines. You will also achieve an increased understanding of paint properties and mixtures (some colours, when mixed, can separate, repel one another, granulate, dominate, cloud or become opaque).

Right: These fallen leaves from a Maidenhair tree (*Ginkgo biloba*) display classic autumnal oranges and browns.

Above and Right: Spring, summer, autumn and winter. In this seasonal colour exercise, spring contains fresh zingy colours, summer's are softer and dustier, those of autumn are subtle in comparison, while winter is cold, drab and even dull. The changes are thoughtfully recorded in the four blocks. Spring contains more greens and yellows. For summer, no colour dominates but all are strong. Autumn contains many oranges and browns. Winter shows predominantly pallid shades of grey, blue and brown.

You may have noticed that you favour certain colours or colour combinations over others. Painters through the ages had their own favourites. Rembrandt loved earthy browns, Van Gogh often used strong complementaries – red/green, purple/yellow – and Matisse loved blues and oranges.

Seasonal colours are both subjective and objective. For instance, while you may associate certain colours with a given season, someone else might not. Some colours are unanimously associated with a season, while others are open to debate. One of the aims of this exercise is to show that each season stands very much as itself and retains its individual character.

You may find this a time-consuming exercise, but persevere as it is well worth the effort. The rectangles can be added to a little at a time, adding colours to each season until all are complete. This method also allows time for you to reflect on which colours to add where.

The juxtaposition of colour is important, as colours affect one another differently, depending on their proximity, amount and intensity. Placing different reds and greens in adjacent squares teaches us how they resonate or not, dependent upon their strength and relationship to other colours. The red/green complementary pair incite one another to brilliance. In the case of holly (*Ilex aquifolium*) and berries, a painting of red berries against green leaves has far more impact than one of yellow berries against green leaves. Note also, if your red berries are too pale, or too dark, the 'brilliance' effect is reduced. If the berries are too far away from the green, then the impact is also reduced.

By placing other colours together, you will learn more about cause and effect, and so will be helped enormously when deciding on certain colour configurations within the botanical context.

You may find it useful to repeat the exercise at a later date. As with most of the exercises in this book, your first attempt may need revising and expanding. Your ultimate aim is to end up with four well-represented blocks that contain subjective elements, but with the overall feel and look of the intended season.

Aim to show the correct separations of colour for each season. For example, the types of greens found in spring appear vibrant, zingy and fresh, whereas those in summer are softer and dustier; and those found in winter are drab, dull and subdued. In fact the whole exercise is extremely beneficial for the study of greens, one of the most important and widely used colours in botanical painting.

Autumn fare

This exercise looks at subject matter from the season of autumn or early winter. The downturn of the year shows nature in a transitional stage. Late autumn and early winter bring changing shapes and textures. Select any seasonal subject matter to study and record. The choice of specimen will be a matter for your individual taste. Think about what you identify with this time of year and how you imagine it being portrayed. Consider ripened fruits (apples, pears, plums), fungi, decaying matter (dead leaves) or autumn vegetables (pumpkins, gourds). You can choose one subject or a group such as berries, seeds or different leaf shapes.

Below: This small study of 'conkers', the fruit of the horse chestnut (*Aesculus hippocastanum*), gives examples of highlights, overlaying of browns and the tender treatment of the soft lining of the husk compared with the protective spiny outer casings.

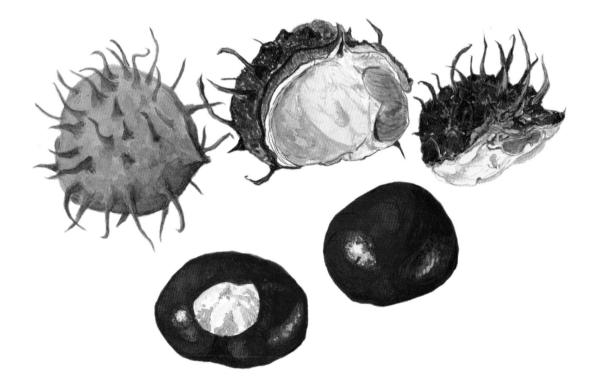

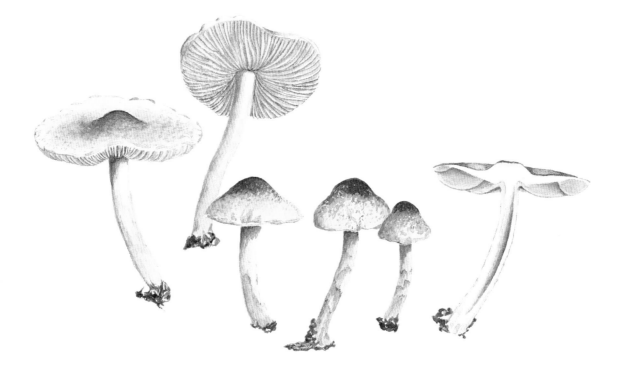

There will be plenty of subject matter to call on. For example, you may associate camellias with burgeoning winter. If you choose to represent camellias, you should practise showing the texture of the petals and the shine on the leaves. The same goes for holly, if that is your choice. Or you may consider berries and nuts as autumn fare. Again, a waxy or shiny surface will allow you to practise highlights. When making your choice, note the differences between what is at its best and what is decaying or in the process of change or decay. Also, note what does not appear to alter much seasonally, such as lichen. Note the differences between slow change and rapid decay and make comparisons.

In this exercise you will be looking at composing an element or elements in a format; thinking about how you place things, and why. Decide what looks good or not and give reasons for what you do. Make notes first in your layout pad and design a page around your autumn choice. As always, do not be afraid to make mistakes.

You may have a design done loosely in your layout pad that you wish to transfer to your sketchbook. Use whatever method you find most practical to your own personal *modus operandi*. Once you have decided on your design, work it up into a painting as you learned in earlier chapters.

Above: This rather unusual fungus found growing at Eden is a *Lepiota* sp. The shape of the cap and the disposition of the gills are significant factors in identification. It is always useful to illustrate a cross section through the cap and stipe (stem). In this case the stipe is hollow and the gills are regularly edged, free and have a strong, yellow colouration.

Right: This unidentified fungus at Eden is shown in all stages of its development. The darker stipe (top right) indicates a specimen that is past its best and beginning to decay. Splitting in older caps can be a useful diagnostic feature. Both this fungus and the one above have been sent for their species to be confirmed by Royal Botanic Gardens, Kew.

Above: The gourd (*Cucurbita pepo* 'Yellow Crookneck') has a warty skin and a dry, twisted stalk. The lumpy texture of the skin is portrayed by superimposed yellow and orange washes, while the shadowed areas have been picked out with browny-purple paint. Note the light source and how dramatic the shaded area on the right looks.

Above and Far Right: Two very different studies of holly (*Ilex aquifolium*), which demonstrate the treatment of complex leaf shapes, shine and the dramatic contrast of two complementary colours, red and green.

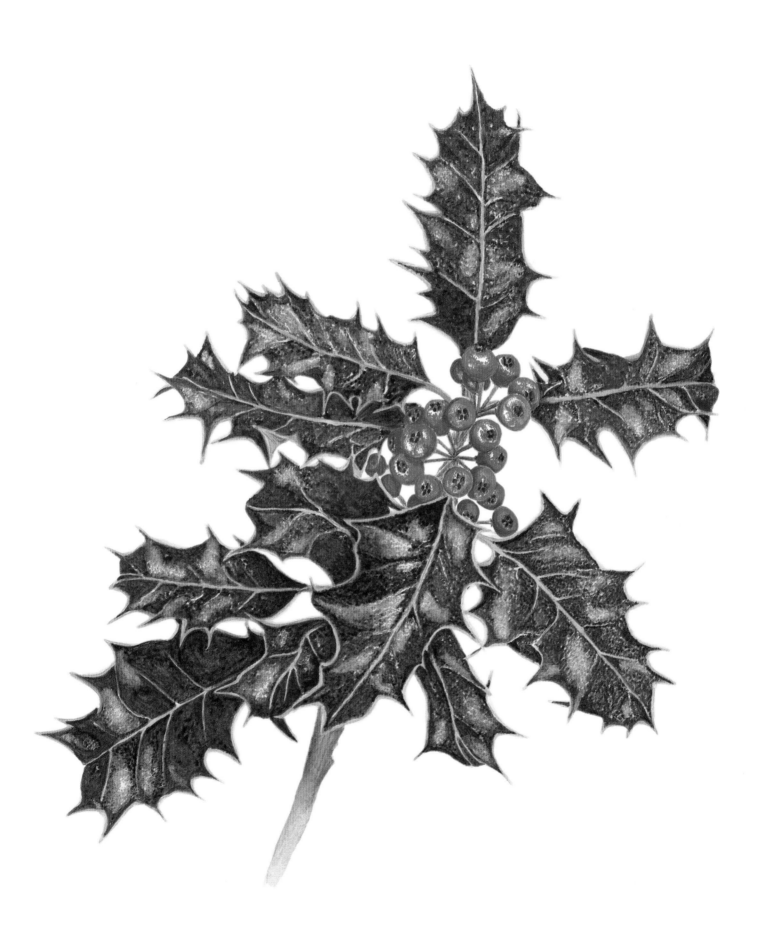

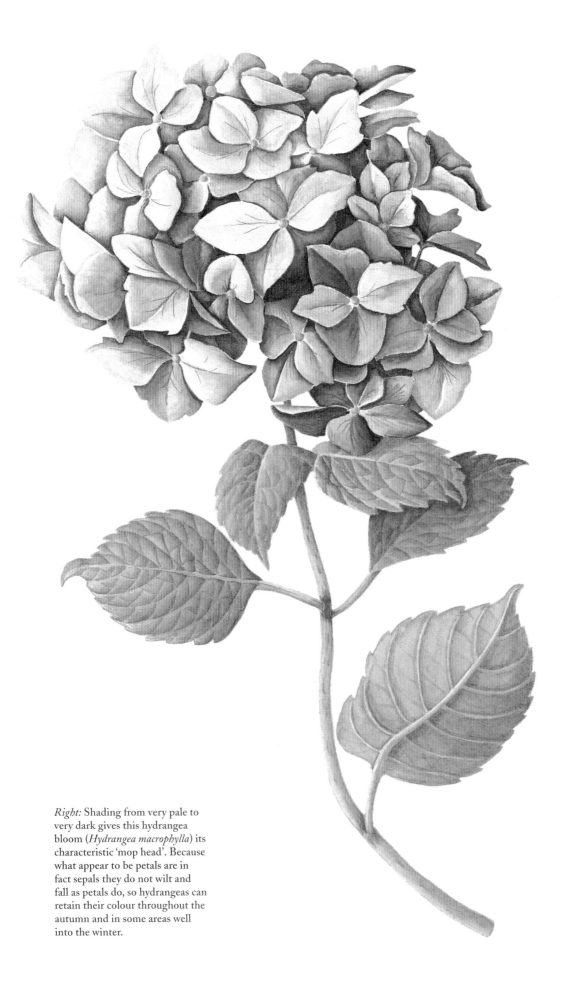

Right: Shading from very pale to very dark gives this hydrangea bloom (*Hydrangea macrophylla*) its characteristic 'mop head'. Because what appear to be petals are in fact sepals they do not wilt and fall as petals do, so hydrangeas can retain their colour throughout the autumn and in some areas well into the winter.

The apple revisited

While you are thinking about autumnal specimens, it might be a useful exercise to revisit an earlier task and draw the apple again (chapter 1). After completing this revision exercise and making comparisons with your earlier drawings, you will be able to see how much you have learned already about observation, draughtsmanship and pencil control.

Without looking at your first apple drawing, follow the instructions exactly as you did for the earlier exercise. Position your apple to its best advantage. Check its size, shape and blemishes. Note any surface markings, their shape, texture and colour. Draw all these in lightly.

Things to note this time are: your increased awareness of the subject and which pencil techniques are required; what works best and why. Consider whether your ability has increased in extent, such as in tonal range and pencil sensitivity. You may now have learned to think of your pencil as a tool, rather than something you grab to jot down or write with.

This exercise is mainly for 'before and after' analysis. When you have finished, compare both drawings, your present one and your first attempt in chapter 1. Ask yourself what was your level of awareness and understanding of observational, drawing and pencil techniques when you started and what it is like now.

You may find that you complete your apple in half the time you took in the first attempt because you are now so much more confident.

You might like to paint the apple as well as draw it. All the same observations need to be made, but this time you will make a very light pencil drawing, noting any highlights, striations and blemishes. Use your initial wash and graded shading to give roundness to the apple, painting round the highlighted areas. Remember that striations and markings usually follow the contours of the apple, whereas blemishes may not.

All the exercises and practice you have done up to this point should now be paying dividends and many of your original objectives will have been achieved. To recap, these were to enhance your observational capability and overall attention to detail; to increase your ability to portray accurately what is there; to increase your understanding of the pencil as a tool and your awareness of texturing, shading, tone, line drawing, types of drawings and their uses. You have put colour theory into practice both diagrammatically and in the form of a complete painting.

Right: Study of an apple in pencil
(see also overleaf).

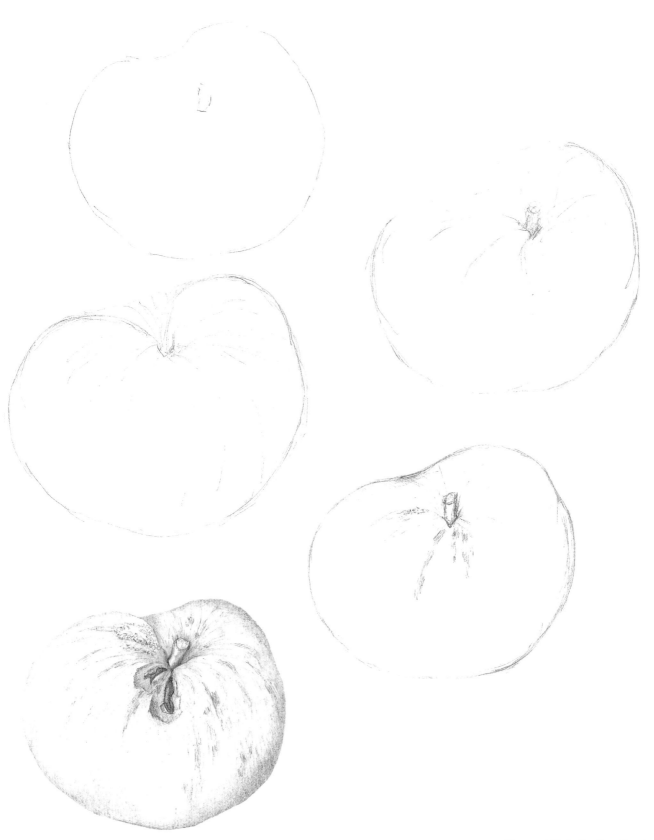

Above and Right: Studies of apples in pencil and in paint.

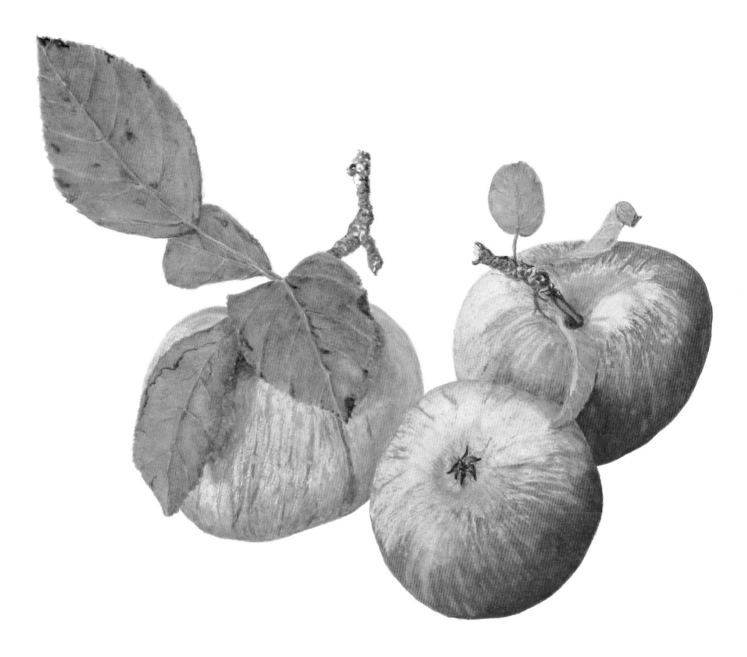

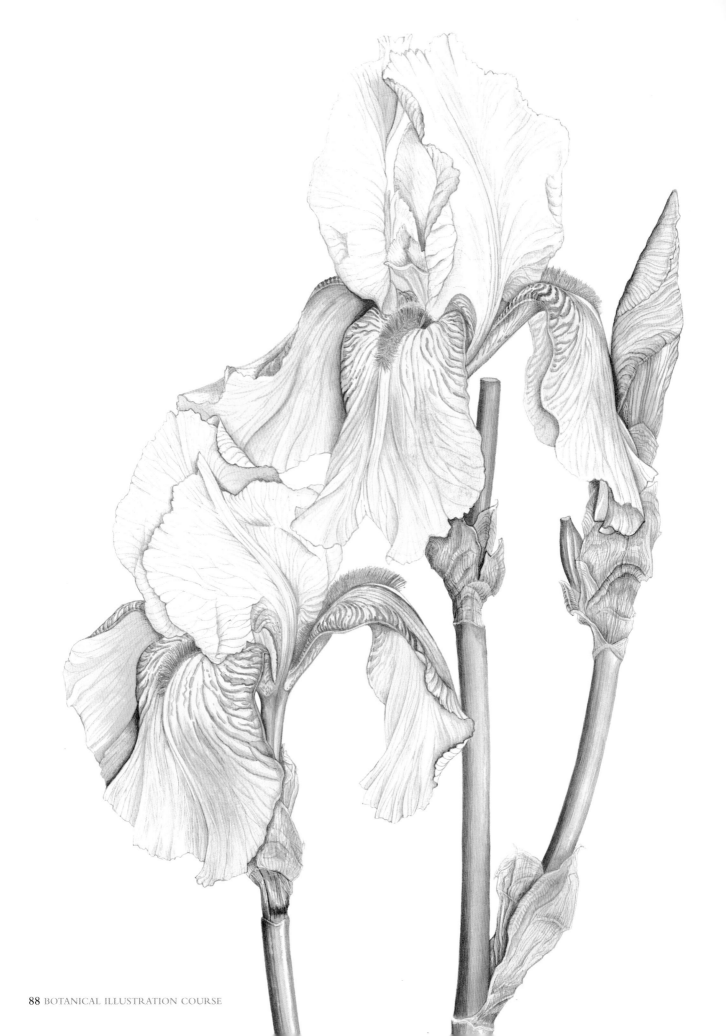

10. White Flowers

The notion of painting white flowers on white paper without using white paint sounds entirely paradoxical. In nature, true white is suffused with reflection and shadow. A white anemone in a woodland setting picks up subtle shades from around it – greens from leaves, blues from the sky. As you will see from the following exercise where you will be painting a white flower, the white paper acts as the painted shape and it is the clever use of greys, pastel mixes and positioning of foliage that bring forth the three-dimensional image of the flower.

Greys delineate the outer shapes of petals or other flower parts and also demarcate overlaps and cast shadow. This magical technique seems to make something out of nothing and often creates the optical illusion that the flower appears to be whiter than the paper around it. The use of foliage is another way of creating a white shape, because when leaves are placed behind petals, the petals immediately seem to stand out and come forward.

To help identify areas of grey or pastel shades, draw your white flower and use pencil to shade in lightly those areas requiring tones. Then decide on your washes. You may wish to drop paint in wet-into-wet, taking care not to let paint stray into areas where there is no tone. Or you may choose to paint a pale wash to begin with, let it dry and then darken parts either by blending with a damp brush, or by gentle stippling or hatching. Paint those areas shaded in pencil. You could carefully pick out the edges of the petals in pale grey, but outlining too heavily reduces the three-dimensional effect.

Left: Painting white flowers. The white paper acts as the painted shape and it is the clever use of greys and pastel mixes that brings forth the three-dimensional image of the flower. This iris illustrates a very complex use of various greys and pastel shades.

Right: Outline the petals of a white flower only lightly, as anything heavier reduces the three-dimensional effect.

Left and Right: Lily (*Lilium* sp.) in pencil and paint. Note how the composition has changed from the preliminary drawing (left) to the finished picture (right). The bud in the background has moved and opened (this latter may be due to the time elapsed between drawing and painting). A leaf on the right behind the bloom has been folded to contain it within the margins. When green leaves are placed behind white petals, the petals seem to stand out and come forward. Notice how the corolla of the lily is given depth by strong greeny-grey shading.

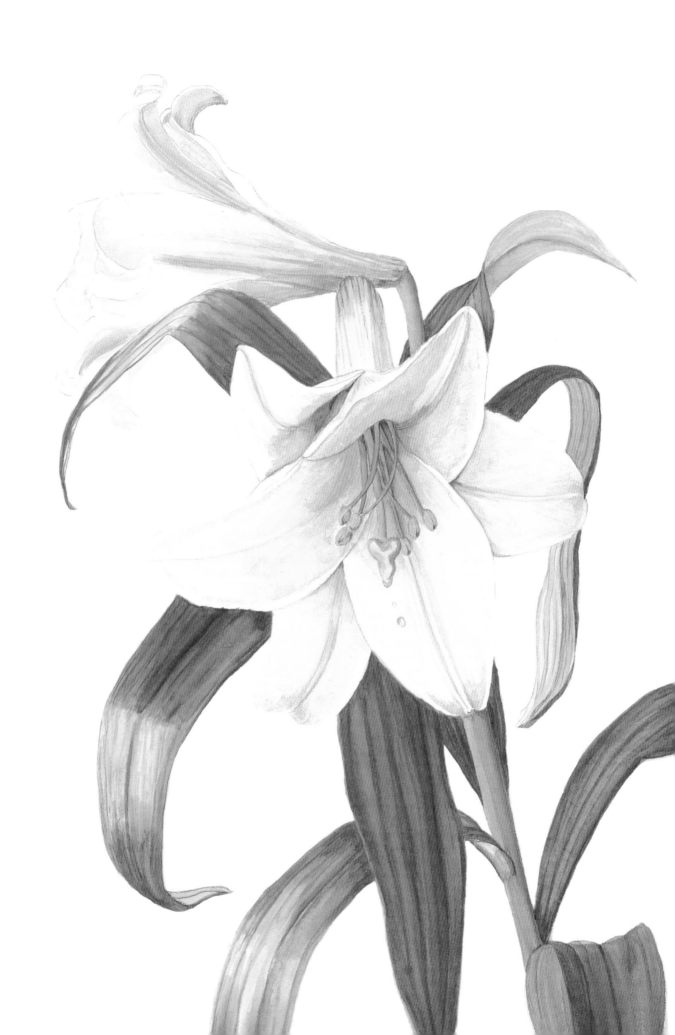

This exercise helps familiarize you with where tone is needed; and pencil does, after all, produce a series of greys. How you modulate your pencil shading will automatically dictate where tone is required. Where the grey in the specimen is not the same tone as pencil, consider just what the shade is – pearly-grey, slate, green-grey, pink-grey, ochre-grey, etc. After painting over the pencil marks, wait until the paint is completely dry and then carefully erase the pencil work to reveal the paint shades. You will soon see if your paint is in the right places and is accurate.

Practise mixing different greys and applying them by blending or stippling relevant areas. This is particularly useful for painting white flowers. It is important that the correct shades of grey are mixed; greys that are brownish can easily dirty a crisp, white flower. It can be more effective to use a neutral or even a bluish-grey as an initial overall shade and then to apply small areas of other grey shades (including brown if necessary) as required. To mix a neutral grey, equal amounts of the three primary colours are used. A little more of one primary will result in a tinted grey: more blue will give a slate or green-grey; more red will give a purple or rusty-grey; more yellow will result in a green-grey or brown-grey.

One of the main pitfalls to watch out for as you work is over-coloration, particularly in the case of very small flowers. It is all too easy to keep adding yet another touch of grey here and there, perhaps to 'put something right', and before you know it the entire flower is grey with no trace of white left! And you will find that it really is not advisable to try to remove grey once it is on the paper.

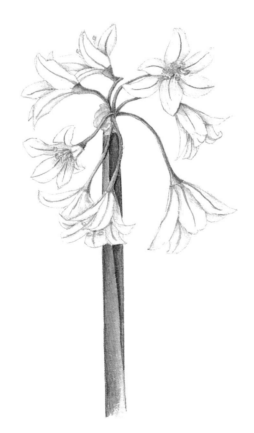

Right: Greeny-greys have been used to give this Ransoms bear garlic (*Allium ursinum*) its cool appearance.

Far Right: Medlar (*Mespilus germanica*). A good example of a flower backed by foliage. Grey paint has been used with good effect to paint carefully between the filaments in the centre of the flower. Fine work like this is best done using a magnifying glass and a very small brush – 2/0, 3/0 or even 4/0. This specimen was picked after a spell of high winds, which had caused the petals to bruise; the bruises have been indicated with touches of light brown paint.

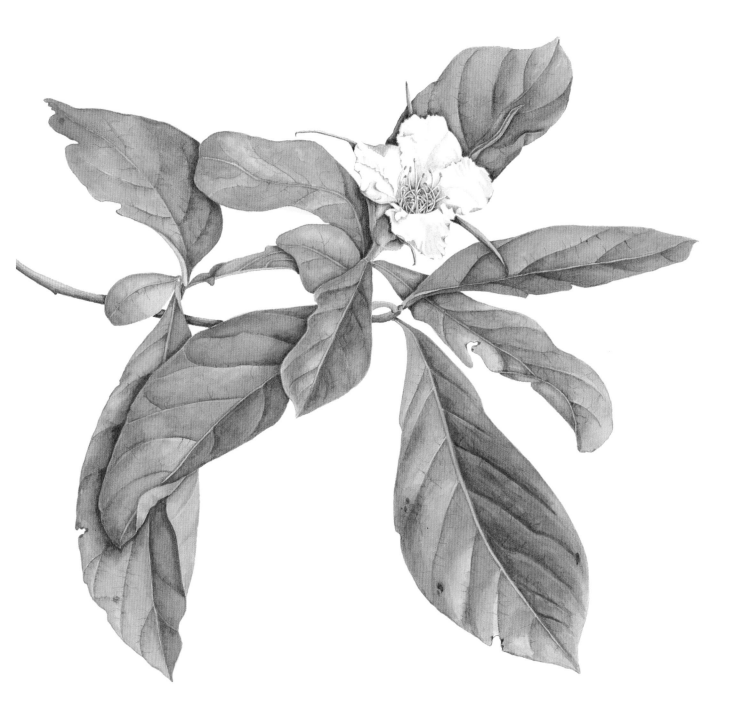

You could experiment with watercolour over pencil for this exercise, using the graphite as tone. As with watercolour, tones can be built up from light to dark in pencil (as you saw in chapter 1) and then any shades of colour are added over it in paint. You will find more practical advice about this technique in chapter 12.

Painting white flowers on white paper takes time and patience to master. Finding the correct grey is all-important. It is very useful to study other artists' examples of white-on-white flowers. Note the sheer range of greys, off-greys and pastel shades, their intensity and amounts used. Study how foliage is used to surround or frame subjects, reaching a balance between foliage and grey tone.

You will find that some artists favour very little grey, allowing most of the flower to remain unpainted. Others use many different greys, resulting in the whiteness being practically nil in the finished flower. Studying other artists' work will help you to decide how far to go with your greys. You may find the mostly grey flowers to be overpowering, or you may find the same amount to be completely acceptable and indeed dramatic. *Vive la différence!*

Below: Watercolour over pencil is a very satisfying method of portraying white petals on a white background. The pencil allows for delicate treatment of the tones delineating the petal edges.

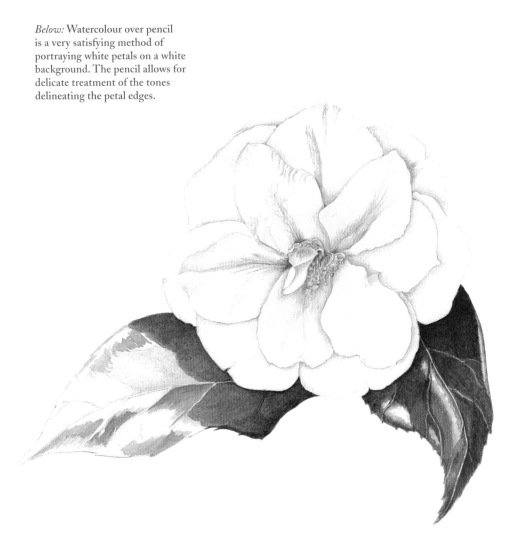

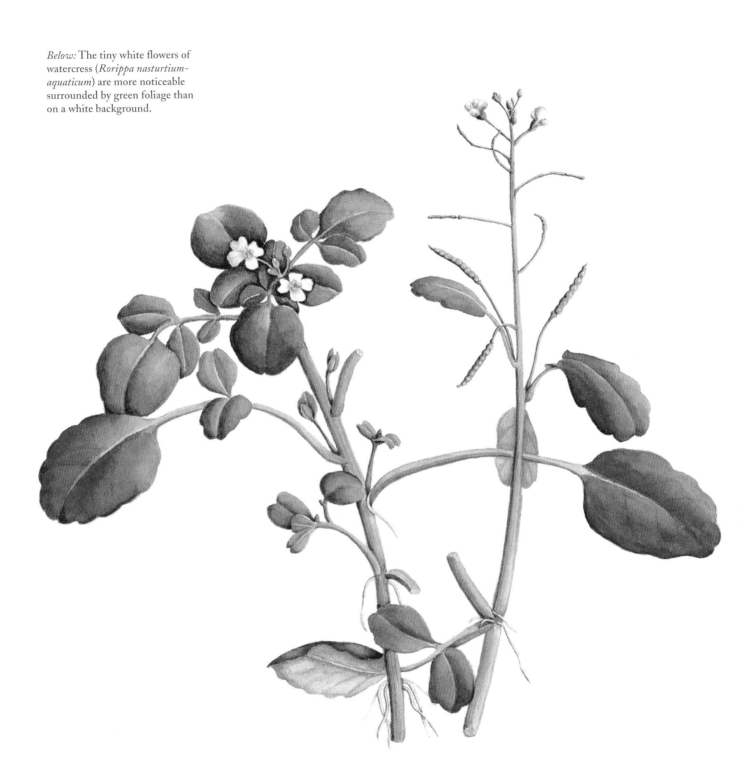

Below: The tiny white flowers of watercress (*Rorippa nasturtium-aquaticum*) are more noticeable surrounded by green foliage than on a white background.

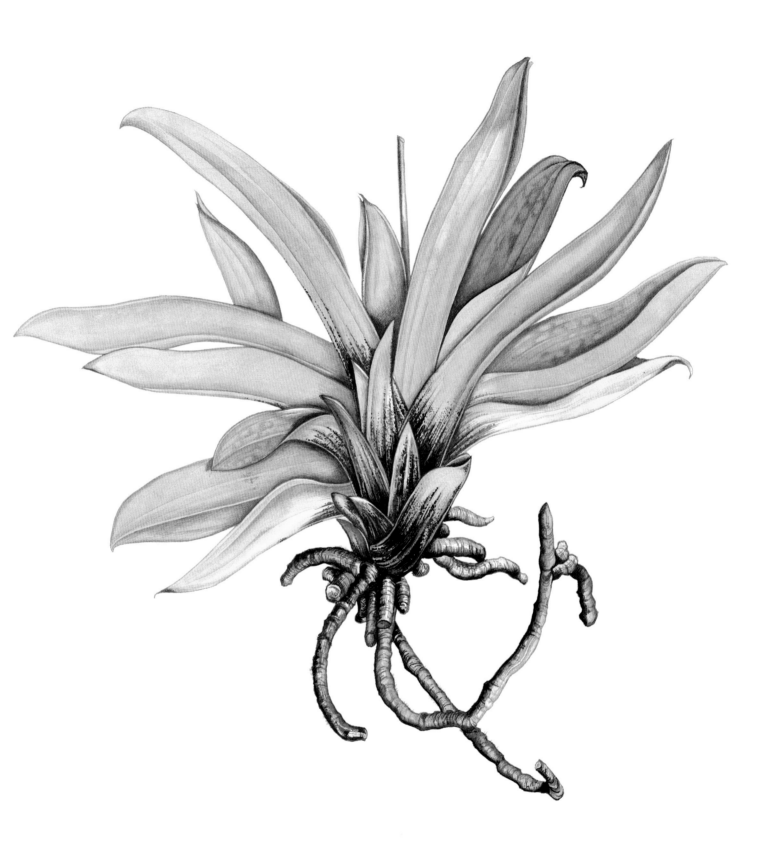

11. Depth and Perspective

In this chapter you will be reviewing all the techniques you have studied so far in relation to spatial perspective: this means painting elements that are further away; elements that are less relevant than others; and elements competing for supremacy.

You will be exploring ways to leave things out, push back, pull forward and highlight using various stratagems, but still follow the traditional notion of showing everything that needs to be shown.

Aerial perspective

Look at a landscape. Notice how things seem to get paler and less well-defined as they recede. This is because the more air (or atmosphere) between viewer and object, the paler and more indistinct it becomes, while the foreground is brightly coloured and contains detail.

This phenomenon is known as aerial (or atmospheric) perspective and is also apparent to a lesser extent in objects at closer range, such as still-life groups or plants.

It is quite helpful to make use of and accentuate this perspective change when painting botanical specimens. It helps you to place plant parts in space (spatial location) and in the format (on the page). As parts of plants recede, such as leaves that are further away or flowers that are towards the rear of the plant, they can be shown using a paler colour or shade, or a bluish shade, or given less distinct markings, patterns or veins. All these variations produce the effect of recession and as long as everything can be seen and understood, and botanical accuracy is still observed, then it is fine to use an element of artistic licence.

Left and Right: Orchid (left) and agave cactus (*Leuchtenbergia principis*) (right). In both these studies, elements to the rear are shown paler and bluer while those in the foreground are more sharply defined and more yellow.

Experimenting with this technique will give you plenty of scope for trying out different shades of the same colour and for practising ways of achieving this atmospheric phenomenon.

Other techniques

Pencil drawing can also be used to place plant parts spatially in a pictorial arrangement. Leaves, as they recede, can gradually metamorphose from paint to pencil. The pencil work, too, can become progressively fainter as the object in question recedes. You can achieve the same effect by using a neutral grey shade of paint and a fine brush – see the illustration Fuchsia (*Fuchsia* 'Lottie Hobbie') on page 100.

You may feel that the interpretation of your subject can be enhanced by leaving out elements completely or partially. If elements of a plant are treated this way, however, it is important to check that a vital part is not being sacrificed in favour of a visual decision.

You may decide to balance your picture by painting (or drawing) some elements more heavily, or colourfully, or lighter, or darker, or more detailed, and so on.

The woodcuts in medieval herbals were of necessity simple linear portrayals of the basic characteristics of the plants they depicted. Since then expectations and methods of reproduction have improved, and it is now easy to look at a well-executed botanical painting and see a three-dimensional figure, knowing full well that it is in reality only in two dimensions on the paper. Look at it analytically and ask yourself why it appears so well rounded. Are the parts to the rear of the subject painted lighter, or with a bluish shade, or are they perhaps merely pencilled in? Undoubtedly you will find that one or other of the methods mentioned in this chapter has been used, and your own paintings can only be improved by such interpretation of space and format.

Right: A good example of aerial perspective, with warm colours in the foreground and cool colours in the background. This unfinished study is shown enlarged in order to accentuate the detail.

Right: This delicate painting of Fuchsia (*Fuchsia* 'Lottie Hobbie') demonstrates how elements in the background can be shown by the simple use of grey paint. Pencil drawing would give the same effect.

Right: Ivy (*Hedera helix*). The fruits at the top have deeper tones and more detail than the ones behind. First-year leaves have not yet developed the characteristic shape (see chapter 8).

12. Watercolour Over Pencil

Watercolour over pencil is a technique in its own right and is not to be confused with pen and wash, or just putting a watercolour wash over 'any old drawing'. Watercolour over pencil is a careful amalgamation of fine, carefully executed pencil work to show all the tonal changes of a specimen, and deft use of one or more colours painted in various ways over the pencil. This chapter will show you how to practise this technique.

It can be quite tricky to achieve and it is important to use a hard pencil so that the graphite does not dirty or dull the white paper when wet. The pencil work is then fixed with one or two layers of watercolour. If you find you have a linear style and an affinity with the pencil you may well favour this method. It can also be very useful if you wish to work with coloured pencils.

Some top modern botanical painters have made the technique of watercolour over pencil their own after much consideration, refinement and practice. Try to find and study some of their paintings, and analyse their techniques and working methods. (Shirley Sherwood's books include works by contemporary botanical artists who use watercolour over pencil, see Further Reading page 139). A magnifying glass is very useful for examining pencil shading.

The technique relies on the tones of the subject being built up using a variety of pencils ranging from hard to medium hard. The addition of colour washes over the pencil work should not disturb or spread any graphite, hence the use of harder leads.

The paint, applied over the pencil work, can be in the form of a blended wash, a single light wash, several layers of superimposed washes or combinations of all these. Some artists use very hard pencils throughout their paintings to give a soft, pale grey, pearly gleam. Others combine hard and softer pencils.

Left and Right: Watercolour over pencil relies on tonal gradations being built up using a variety of pencils before adding colour with a wash or a series of washes.

Experiments in watercolour over pencil

When you begin to try out this technique it is important to note that great care should be taken and lots of experimenting done in order to understand the behaviour of watercolour and graphite when mixed together on the paper. Some artists successfully exploit the charcoal-like effects produced by graphite and water, but this only occurs when soft pencils are used. Again, a combination of hard and soft pencil can give lovely shades of grey, some of which may move when wet while others will not. Experimentation and patience will ultimately show what looks good and works, and what does not; which effects you personally favour, and so on.

When experimenting, bear in mind that the white of the paper can be left either completely white for highlights or set with a pale layer of paint over lighter areas. The majority of tonal variation (lights and darks) is achieved through pencil shading.

When you are working, the main areas of difficulty to look out for are pencil tonal control; getting the dark areas dark enough; using a wide enough range of tones; and refining the pencil work to avoid showing rough lines or imperfections. You may need to pay attention to your non-directional shading in order to achieve flat, even and smooth areas of light through to dark.

However, if the process works, it is often very difficult to tell the difference between watercolour over pencil and pure watercolour. It is another learned skill, but not one that can be seen as a quicker route or short cut. Skill and judgement are as necessary here as with 100 per cent watercolour painting. You may find that you are more in control of pencil work than paint, just as you find one method of painting easier to control than another. Remember that we are all individuals and there is room for all our personal preferences.

This method of botanical illustration will be particularly suitable for you if you love pencil drawing and if you prefer the bulk of the work to be done using pencil. You may find you like the somewhat sombre finish that watercolour over pencil can give. Used well, the finished results can be subtle yet sharp, with great depth and extreme contrast.

Below: Cactus (*Mammillaria peninsularis*). Watercolour over pencil lends itself to fine, detailed work as exemplified here.

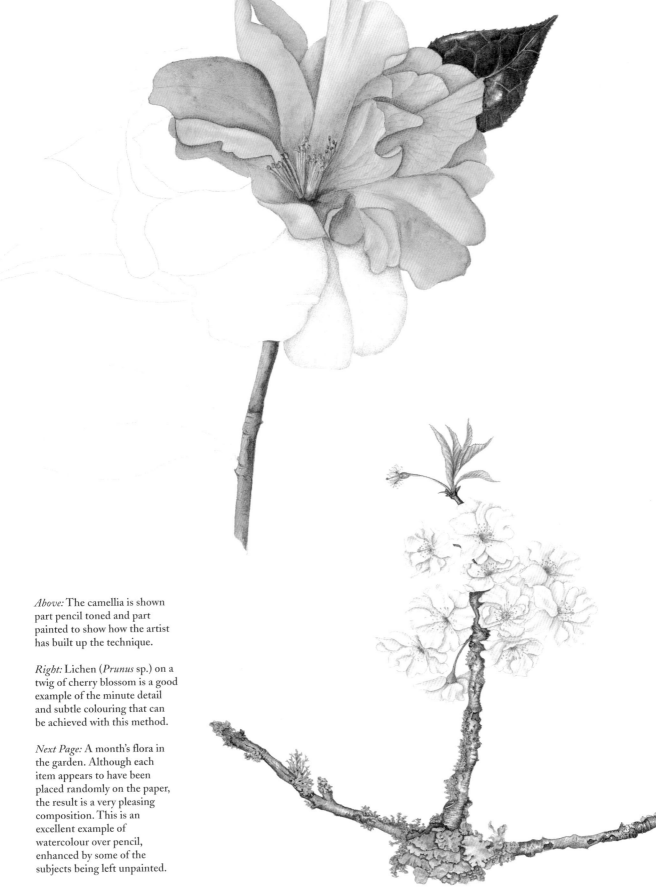

Above: The camellia is shown part pencil toned and part painted to show how the artist has built up the technique.

Right: Lichen (*Prunus* sp.) on a twig of cherry blossom is a good example of the minute detail and subtle colouring that can be achieved with this method.

Next Page: A month's flora in the garden. Although each item appears to have been placed randomly on the paper, the result is a very pleasing composition. This is an excellent example of watercolour over pencil, enhanced by some of the subjects being left unpainted.

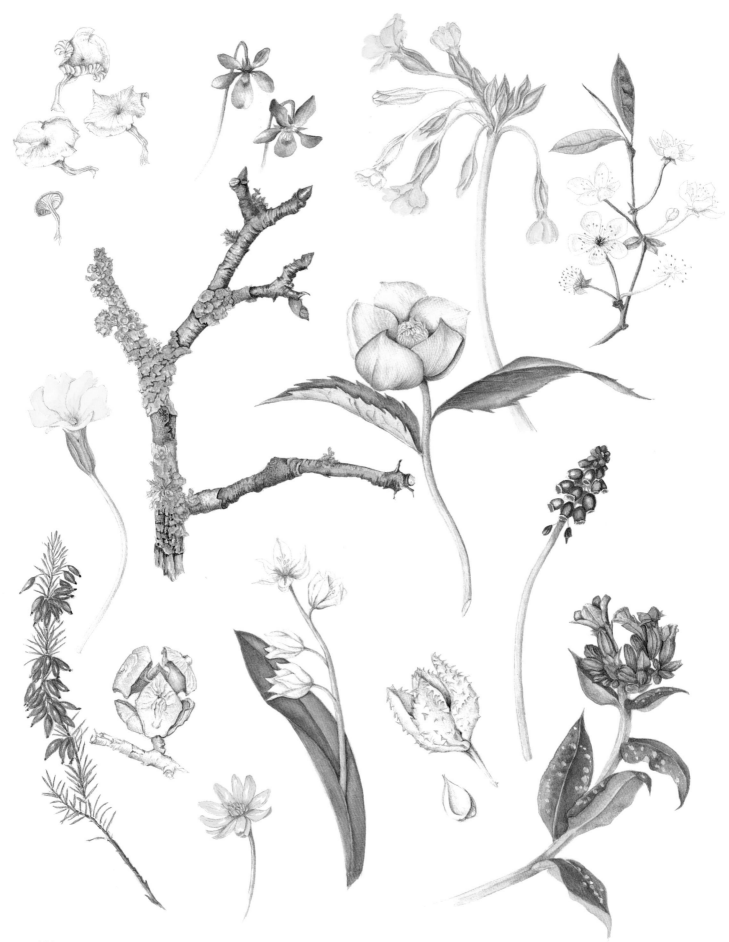

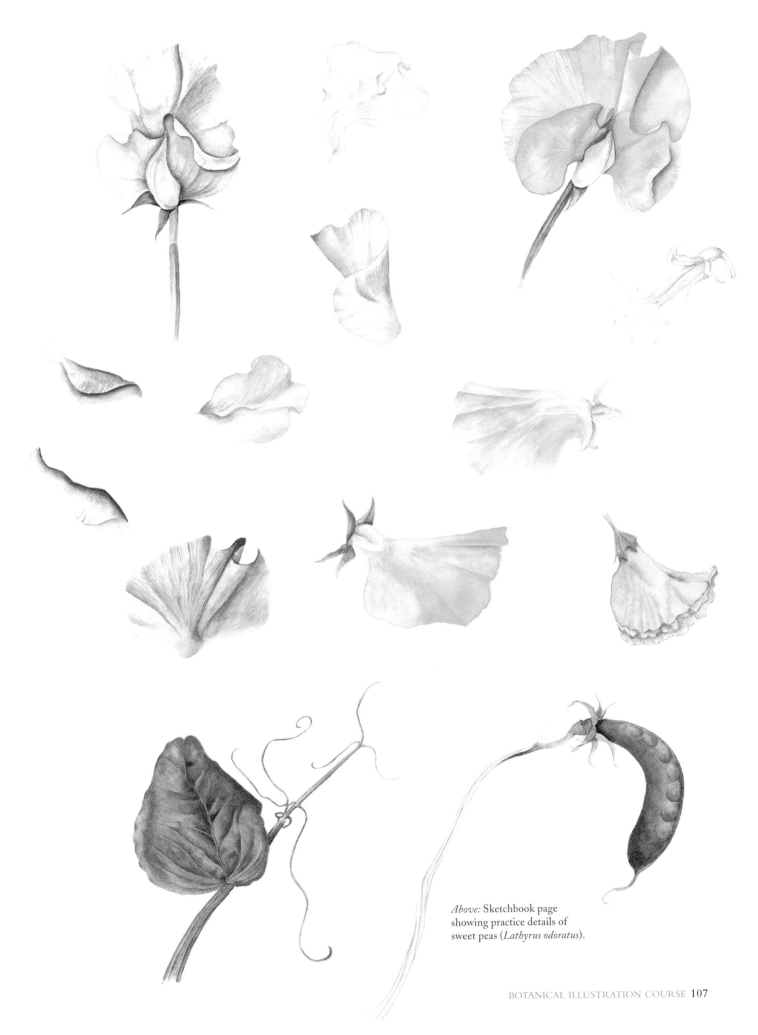

Above: Sketchbook page showing practice details of sweet peas (*Lathyrus odoratus*).

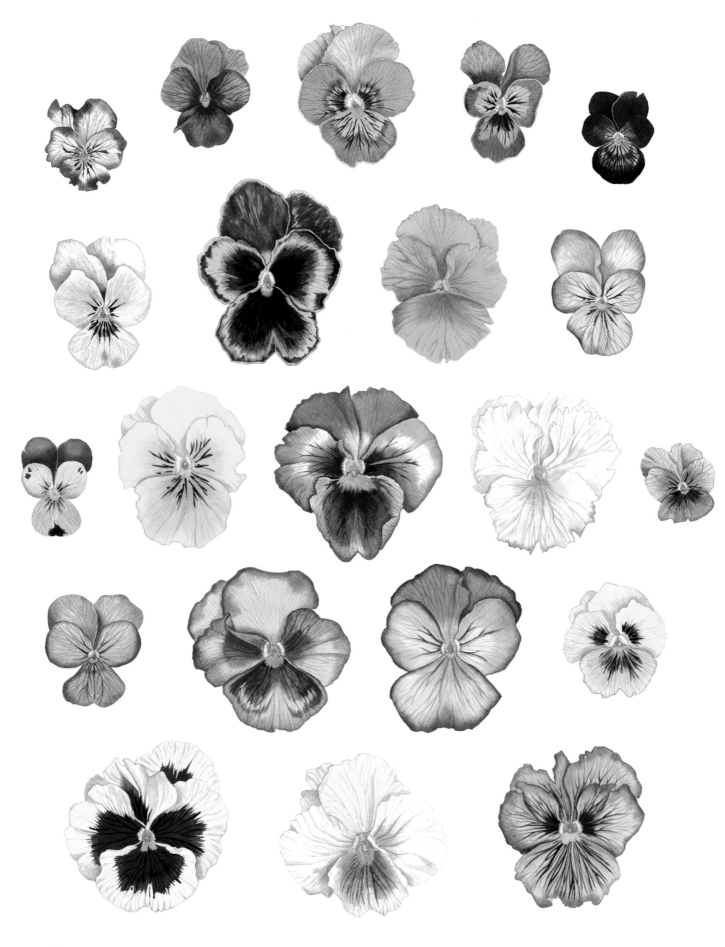

13. More Texture, Pattern and Effects

The different textures and patterns found on flowers, fruit and vegetables can be trials – both demanding and testing. For this chapter choose your specimens from subjects containing the following: translucent skin, bloom, fur, fluff, fuzz, fine hairs, fine lines or veins, velvet texture, deep tones, dark colours, heavy texture or markings and spaces between fine lines.

Consider the translucent skin of an onion or a clove of garlic; the bloom on a plum, grape or damson; the fuzz on a magnolia bud or a kiwi fruit; the fine lines or veins on iris petals; the velvet texture, deep tones and dark colours of pansies or Sweet Williams; the roughness of tree bark; the zesty skin of an orange; the dryness of lichen and dead leaves; the delicacy of skeletal leaves and Cape Gooseberry (*Physalis peruviana*); the heaviness of courgettes and marrows; and spaces between fine lines such as the close bunches of filaments in a camellia flower.

Refer back to your pencil texture exercises and experiments from earlier chapters of the book and then try a similar approach using paint. Your pencil exercises will be helpful; even though they were black and white, there are similarities to watercolour painting because the paper remains white and layers of texture and tone are built up bit by bit, often in the watercolour tradition of light to dark.

Because all these techniques take time to learn and practise, remember that only small areas need to be tried at a time. As with other trials, it is necessary only to paint small sections because anything more would simply take too long.

Left: A profusion of pansies. A vast array of patterns, textures and effects can be found in pansies and violas.

Right: This painting of a string of garlic (*Allium sativum*) shows the fine, translucent, papery skins of the bulbs but also gives the overall impression of heaviness.

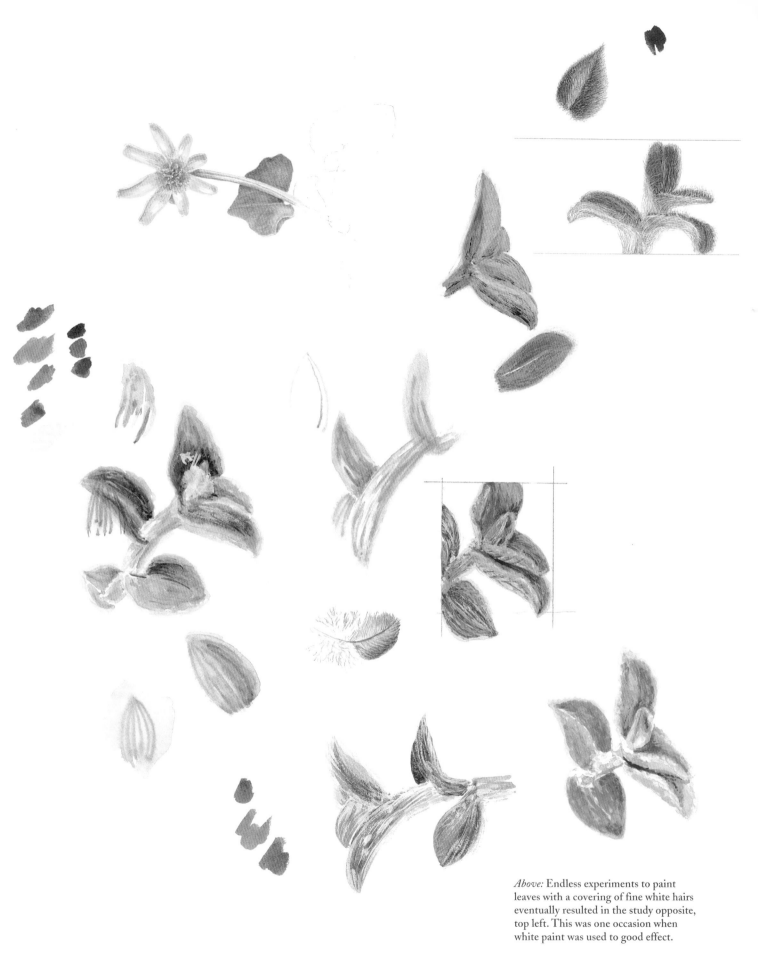

Above: Endless experiments to paint leaves with a covering of fine white hairs eventually resulted in the study opposite, top left. This was one occasion when white paint was used to good effect.

The idea behind these exercises is largely to experiment with different ways of using paint to achieve results akin to an individual specimen. It is an important part of draughtsmanship that each part of a plant be properly observed and recorded – in pencil and paint. If petals are finely veined it is important that the veins are painted carefully or the whole effect will end up clumsy and out of character.

Any special effects also have to be consistent with plant characteristics. For instance, it would not work to use a soft, smooth wash finish for a gnarled apple twig or bark. A stippled, multi-textured approach would better serve the overall appearance. Similarly, to paint in between tubular filaments will generally look more convincing than painting them straight on to the paper on top of other detail.

When choosing your specimens think about the sheer number of textures, patterns and effects shown in nature. For example, you could try to portray the brown fuzzy fur on a kiwi fruit skin. You could choose a leaf with a grey-blue soft, furry surface. Or you could try your hand at painting just a clump of stamens on a camellia, where the stamens are lighter than the petals in the background. To do this, first paint an initial wash in the colour of the filaments. When it is dry, the background colour will have to be carefully painted around them, leaving them untouched.

Above and Right: Examples of different textures – furry, velvety, papery, shiny, translucent. You can almost smell the zesty tang of the orange.

This exercise requires boldness and confidence in paint handling and noticing the different qualities of effects in paint. The more you manipulate the paint, the greater will be your understanding of what is possible. You need to experiment with many examples, using a variety of methods. If one method did not give quite the desired effect, you should attempt other ways – or simply keep trying.

The more you look at things, the more textures you see. Notice what is around you in your everyday life; look at different surfaces and decide how you would depict them. Knitted fabric, a pan scrubber, the knobbly texture of tweed, a lump of concrete, a clump of moss – they all have their individual qualities, which give them their identity, and each one needs to be portrayed differently.

Remember that all the experts in this subject have spent long, painstaking hours practising this exacting and multi-technique art form. Acquainting oneself with the myriad techniques may be one thing – perfecting them is another! If you are patient and practise, however, bit by bit as your paint handling improves so does the acquisition of skills and sense of personal achievement.

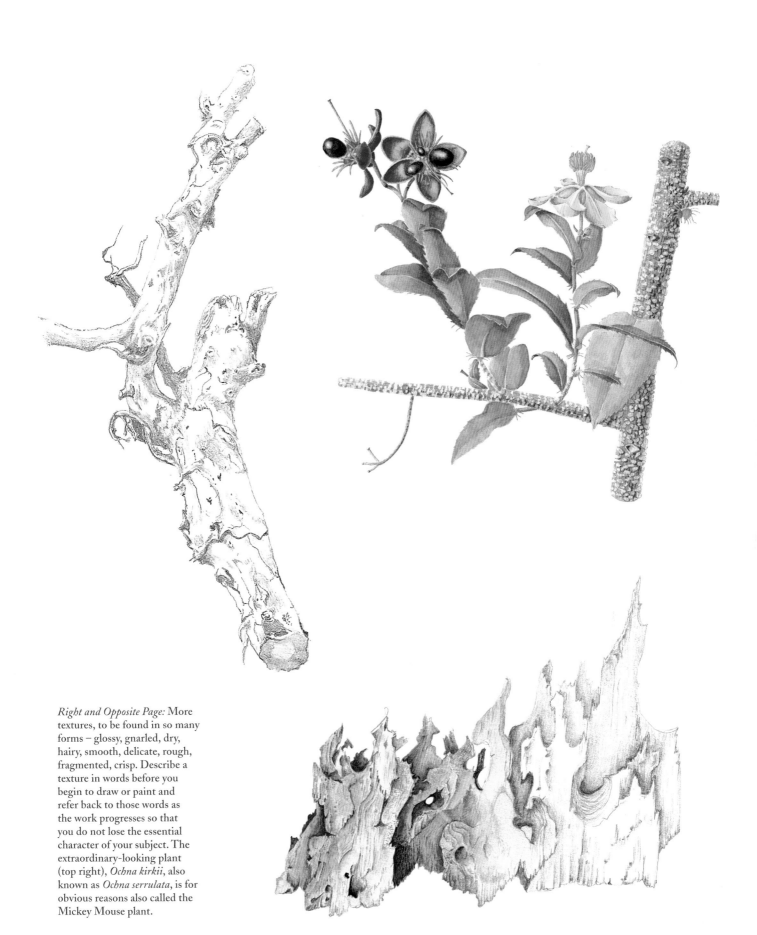

Right and Opposite Page: More textures, to be found in so many forms – glossy, gnarled, dry, hairy, smooth, delicate, rough, fragmented, crisp. Describe a texture in words before you begin to draw or paint and refer back to those words as the work progresses so that you do not lose the essential character of your subject. The extraordinary-looking plant (top right), *Ochna kirkii*, also known as *Ochna serrulata*, is for obvious reasons also called the Mickey Mouse plant.

14. Dissection and Bisection

Dissection is the cutting up of a specimen for minute examination.
Bisection is the dividing of a specimen into two equal parts.

You may be interested in this subject because you want to bring
a more scientific element to your botanical painting and aid correct
identification. Alternatively you may simply wish to be able to
portray, say, the interior of a bloom, root or seed head, to add to the
information in your picture. Indeed, a large subject bisected, such
as the artichoke shown here, can make a complete picture in itself.

You do not need to know about botany to be a botanical artist, but some
people do find that knowing the names of the various parts of a plant or
flower enables them to understand it more clearly and therefore portray
it more accurately.

In this chapter we show various different flowers, both whole and
bisected. If you are hesitant to tackle something complex, with fine
stamens or petals, consider using something simple like an orange. Cut
it 'through the equator' with a sharp knife for the best section view.

When bisecting and dissecting small or delicate specimens you will need
a razor blade, fine craft knife or scalpel. It is important to make a clean
cut, particularly through a narrow style, anther or filament. If the cut is
not clean, visual information can be misleading or lost.

Left and Top Right: Bisections are often
strictly functional, as with the Easter
lily (*Lilium longiflorum*) (top right).
However, the globe artichoke (*Cynara
cardunculus*) (left) makes a picture in its
own right. It was picked on a visit to
Brittany, France, where it is colloquially
known as 'Petit Violette'.

Right: The component parts of a flower.

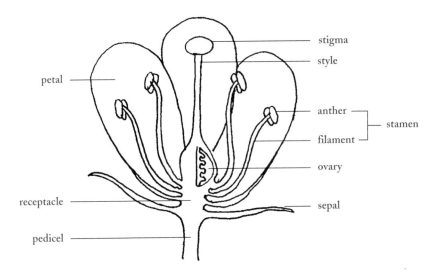

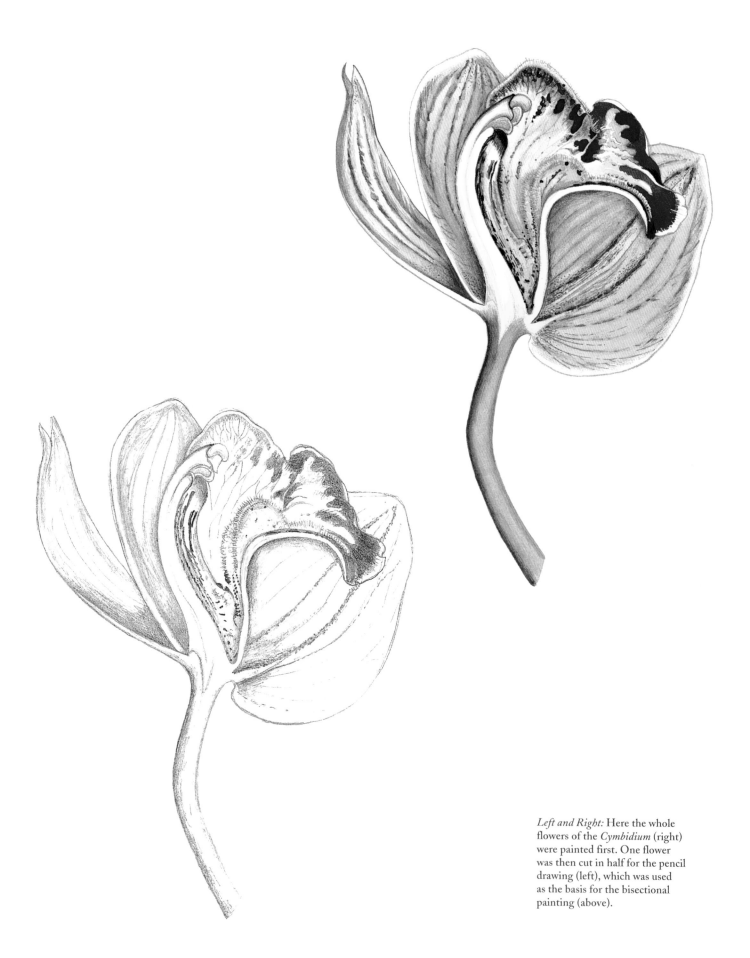

Left and Right: Here the whole flowers of the *Cymbidium* (right) were painted first. One flower was then cut in half for the pencil drawing (left), which was used as the basis for the bisectional painting (above).

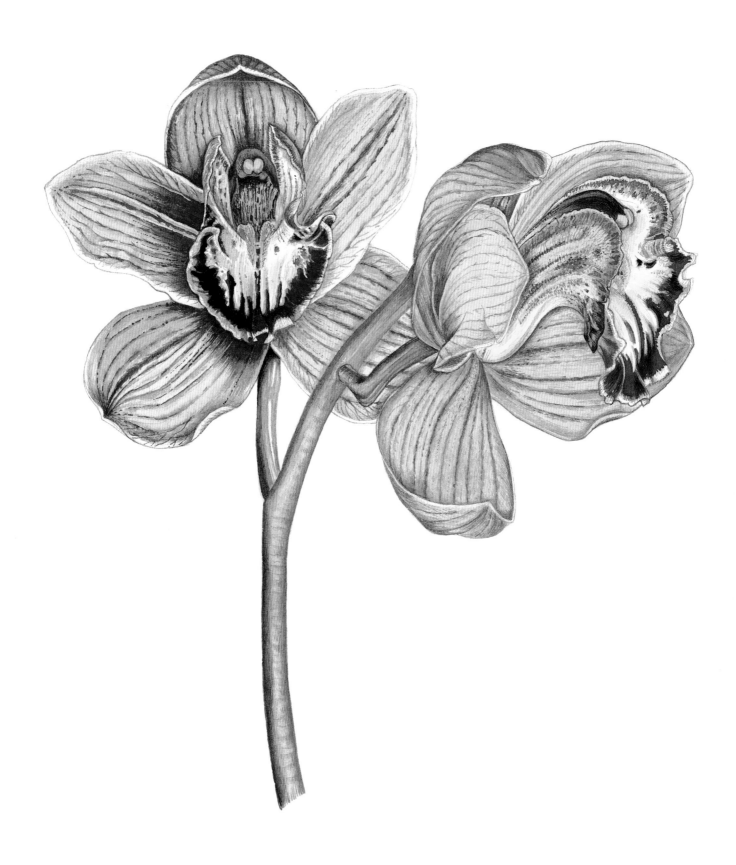

While dissecting and bisecting specimens, observation is all-important. Accurate measurements are vital. Use your dividers to transfer measurements to the paper. A magnifying glass is very useful too. You should make quick sketches as you work, to determine the scale, angles, form, situation and relationship of all the different plant parts one to another.

You must work as quickly as possible because of the rapid deterioration of the bisected or dissected parts. Use of a digital camera can help, providing the images are clear and concise. Note also the importance of the double or parallel lines that demarcate separate areas of the flower seen in section.

It would be very useful to look at examples of different plant parts under a microscope. Try not to be squeamish about this: specimens have to be taken apart in order to examine them properly. Study your pieces carefully before drawing them, noting all the time the scale of the visible parts.

Drawing accurately while using a microscope is extremely exacting and, while we have touched briefly on the subject, it is not something that can be dealt with in a few short paragraphs. Further study of this comes under the heading of botany (see Further Reading, page 139). Many botanical artists work extremely successfully with only a limited knowledge of the subject.

Above: Examples of plant part drawings as seen under a microscope include dandelion seeds (*Taraxacum officinale*), fine hairs and details of the cellular structure of the underside of a leaf.

Right: Enlarged plant components add to the composition of this drawing of a Japanese anemone (*Anemone* x *hybrida*).

x3

x6

x18

x6

x1.5

x4

Right Ornamental pineapple (*Ananas comosus* var. *variegatus striatus*) shows the segments partly hidden. It was therefore necessary for the initial drawing to be extremely accurate. Page 123 shows the artist's test page.

15. Pineapples, Fir cones and other Complex Forms

Many plants are designed around the spiral; the centre of a sunflower, fir cones, pineapples, cacti and artichoke flowers are all underpinned by this geometric formation. The natural spiral formation has been found to relate to a sequence of numbers known as the Fibonacci Series.

The Fibonacci Series

The Fibonacci Series is the series of numbers (1, 2, 3, 5, 8, 13, 21, 34, 55, 89, 144, 233, etc) where each number in the series is the sum of the previous two. (So 2+3=5, 3+5=8, 5+8=13, 8+13=21, 13+21=34, 21+34=55 and so on.) The numbers have huge relevance in nature. You only have to look at the spirals on certain shells, at pinecones and the arrangement of petals on flowers to find the Fibonacci Series. For example, buttercups have 5 petals, delphiniums have 8. The centre of the sunflower has two series of spirals winding in opposite directions; the number of spirals varies, but they are always adjacent numbers in the series: 21 and 34, 34 and 55, 55 and 89, or 89 and 144. The same goes for pine cones, which have either 8 spirals in one direction and 13 in the other, or 5 spirals in one direction and 8 in the other. Similarly, the number of diagonals in a pineapple is 8 in one direction and 13 in the other.

This curious arrangement is simply nature's way of filling space most efficiently, ensuring optimum exposure to light and water for the plant. Knowledge of the Fibonacci Series is helpful for any botanical artist who wants to reproduce a plant form faithfully, such as a sunflower seed head or a complex cactus. (More information about the Fibonacci Series may be found on the Internet.)

Right The spirals of an artichoke (*Cynara cardunculus*), pine cone or pineapple (*Ananas comosus*) can be plotted as a series of diamonds to aid identification of the overall structure of the plant.

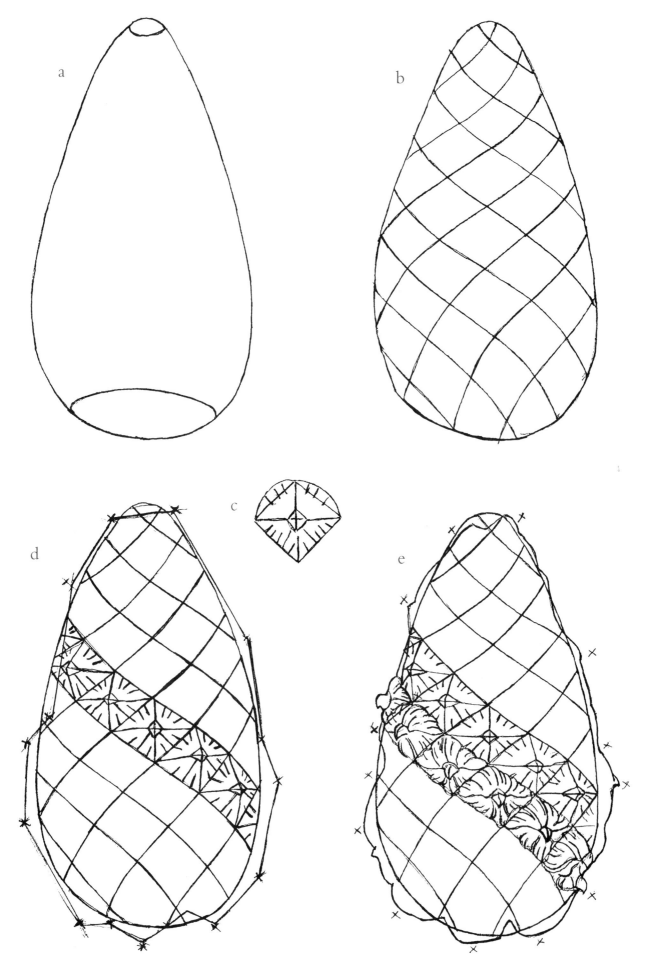

Using a spiral skeleton

Many students, when confronted with a complex form, such as a pineapple, can be heard to groan or say 'where on earth do I start?'

We suggest you use the five stages of construction shown in the diagrams opposite:

a The basic three-dimensional form.
b The basic outer shape of a cone, with spirals running in two opposite directions.
c The basic construction of a full-frontal segment.
d The same, with a row of basic construction segments and slight refinement of the outside shape. Each directional change is marked with a small x.
e The same, with two rows of segments – the top is the basic construction and the bottom is fully refined. Refinement of the outer shape is optional and can be used as a guide in pencil to be erased later when all the segments correspond. This is helpful because it is easy to lose your way when locating segments.

Remember to check that everything works together. Is the basic form spherical, elliptical, cylindrical? It might need adjusting before spiral lines are placed. When laying out the initial drawing, make sure that the diagonal lines correspond with your particular specimen. Determine the number of spiral lines and segments. If you just rely on a framework, the actual number of spirals and segments will not match up. Pay particular attention to perspective shift (the apparent distortion of individual shapes) as the eye travels from front to sides.

In some instances, the surface texture of the plant can make it hard to follow the spiral pattern. On the ornamental pineapple, for example, individual segments can be obscured, thus confusing the overview. In the same way, the bracts of the large artichoke on pages 128 and 129 are so decorative and foreshortened that they obscure the skeletal spiral. You may find that while concentrating on each individual segment, it is helpful to mark it in some way to avoid confusion as your eyes travel back and forth between the specimen and the paper. Pins, sticky paper, masking tape, coloured felt-tip pens or dabs of paint can all be used to mark the individual segments.

Left: The five stages of construction of a complex form.

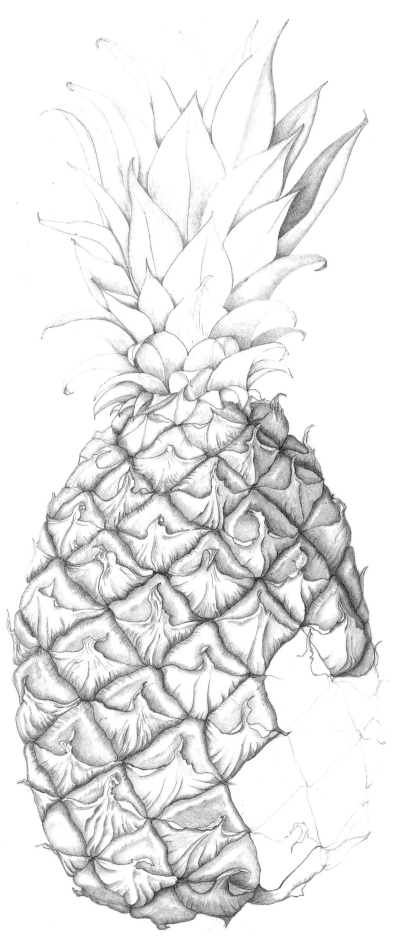

Right: In order to understand the complex form of, say, a pineapple (*Ananas comosus*), it can be helpful to complete a detailed pencil drawing before starting your painting. Here we compare a pencil drawing and a painting by two different students.

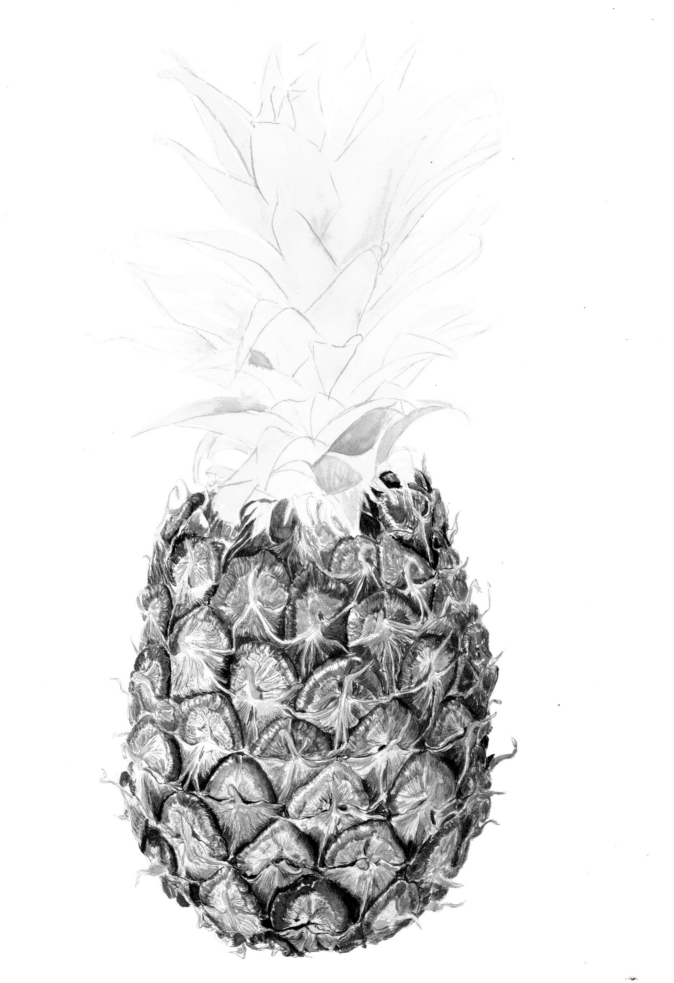

If you are having extreme difficulty in working out the structure of your subject, don't be afraid to use an artificial aid to achieve an accurate drawing. Sometimes the task of trying to draw a complex object becomes so daunting that you might be forgiven for, say, enlarging a photograph using a photocopier or computer until it is the correct size for your finished drawing. You could then either trace over it or use a light box to establish where all the details go. Take care that by doing this you do not detract from the individuality of the specimen in the finished picture, or compromise your training as a botanical artist.

Before you paint the first segments, check your light source and your painting order. Make sure your special effects (if any) will work; for example, tiny highlights around the segments should be left white. Test all your effects before committing to the finished picture – even complete a whole segment. A badly painted segment in pride of place can glare back at you for ever more.

As you paint, keep stepping back from your work so you can carefully examine the overall shape, the geometrics and individual sections within the whole of the plant.

They are known as complex forms, and this is a complex subject. However, don't be intimidated by it. Take it one step at a time. Place your specimen in its most favourable position. Make sure it is well lit. Sit comfortably. Decide how best to portray it on paper, making initial rough drawings of the whole item in your layout pad. Then select one small area and make a practice drawing or test painting to see how the segments and textures fit into the overall shape.

By taking it one small step at a time, you will build up your knowledge and produce a satisfying painting.

Right: Worksheet for Globe artichoke (see pages 128-129). Don't belittle the importance of a worksheet on which you can try out colours, textures, types of wash, brush strokes and small sections of the subject. By doing this you will have a clearer idea of how to set about your painting. A badly painted segment in pride of place can glare back at you for ever more. This worksheet also demonstrates how to paint dew drops.

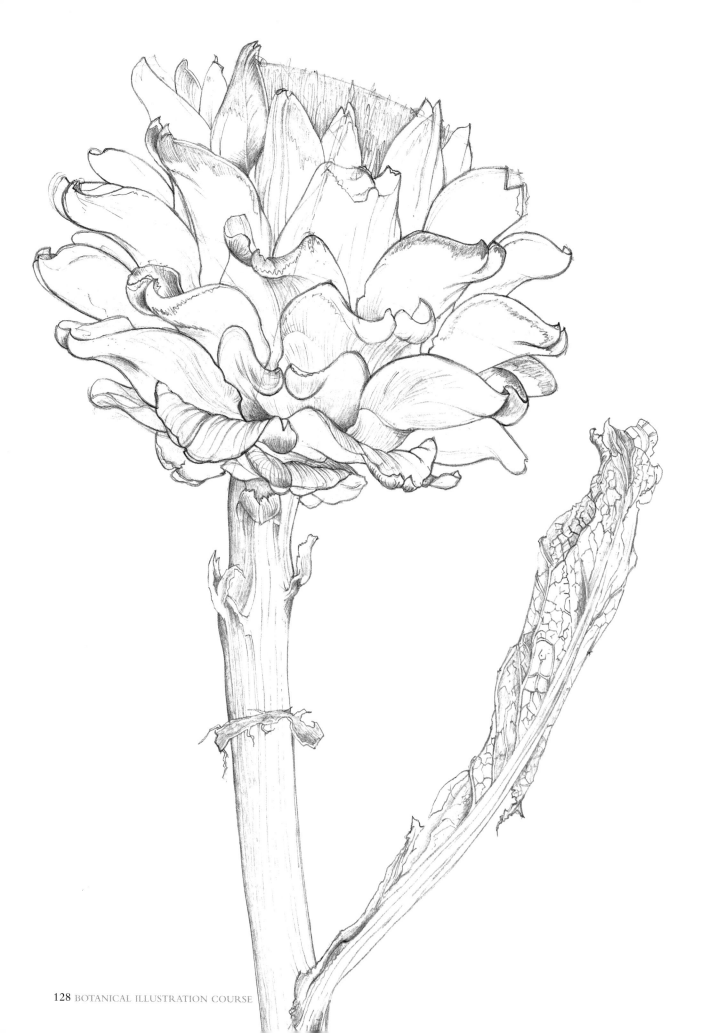

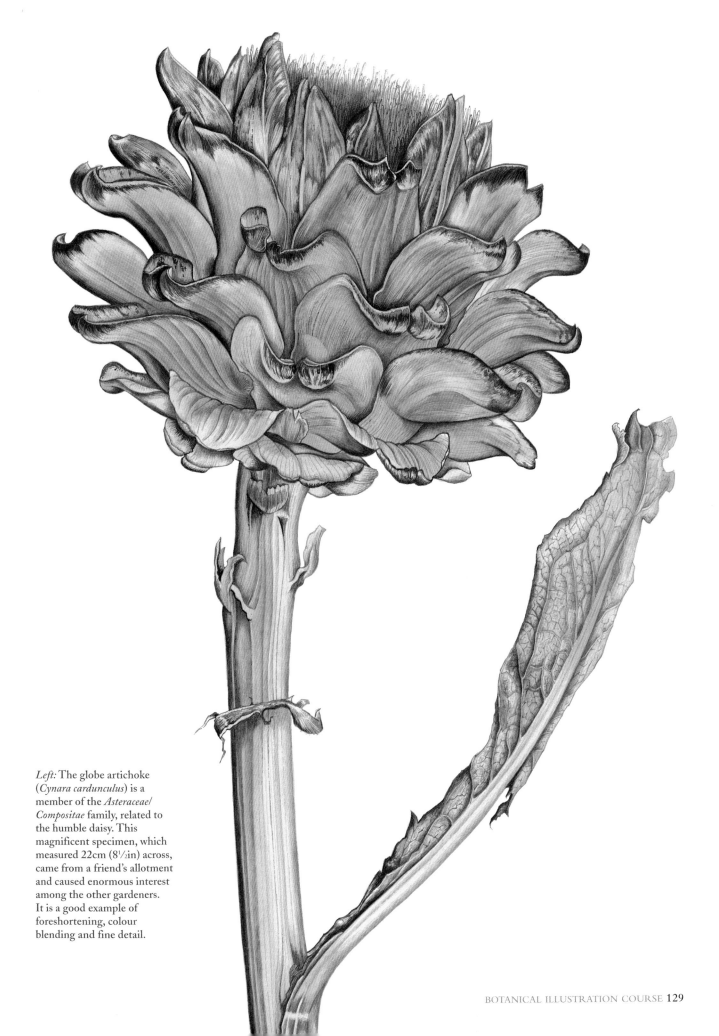

Left: The globe artichoke (*Cynara cardunculus*) is a member of the *Asteraceae/ Compositae* family, related to the humble daisy. This magnificent specimen, which measured 22cm (8¹⁄₂in) across, came from a friend's allotment and caused enormous interest among the other gardeners. It is a good example of foreshortening, colour blending and fine detail.

16. How to Make your Picture Work

It can be difficult to admit that composition, taking into account the trial and error involved and time spent, is a necessary part of the process of learning the craft of botanical painting. Knowing what is a good composition and what is not so good is usually an aquired skill, as is the knowledge of how to make a mediocre composition better.

Understanding the importance of composition and knowing how to go about it is half the battle. You must know what to look out for and have a few guidelines to use. The great masters such as Leonardo, Rembrandt and Rubens spent considerable time composing their paintings and made many changes at the preliminary sketch stage. This shows the value of taking time to think and evaluate.

Composition in a picture is one of the major elements that make it work for you. It can make or break a painting. A good composition can carry a mediocre painting technique, but a bad composition cannot necessarily carry a good painting technique.

Composition possibilities

In this chapter you will be encouraged to think about possible ways to compose your pictures, starting with a few ideas that are set out below. The cross-permutations are of course endless:

- Group of cut, mixed flowers showing cut stems (1)
- Group of single species flowers showing earth, ground, roots, habitat (2)
- Plant with leaf base only (3)
- Group of flowers in the middle of the page (4)
- Busy, multi-plant-part arrangements dotted around the page or filling the page completely (5)
- Single plant with enlarged front view of flower and bulb (6)
- Continuous display showing new leaf through stages of decomposition to skeletal leaf, mounted together or separately (7)
- Tall plants and ways to break them up into smaller sections (8)
- Single species in landscape format (9)
- Formal portrait as growing (10)
- Subject cropped by edges (11)
- Large, single close-up of a flower head or fruit or vegetable, seed pod, leaf, etc. (12)
- Parasitic plants with host (not shown)
- Tree orchid showing section of tree (not shown)
- Plant stages, such as blossom, foliage, fruit, branch, twig, bark, seeds in bisection (not shown)
- Different stem arrangements with some staying in the picture and some disappearing out of the base (not shown)
- Group of cut, single species flowers showing cut stems (not shown)
- Botanical study with analysed dissected and bisected parts – separate the subjects on one page (not shown)

Subjects lend themselves to different styles of portrayal. For instance, a large beetroot or cabbage is so striking that it may simply need placing to its best advantage, whereas fungi could be shown growing in a group complete with the various elements of their habitat.

Alternatively, a month's flora in your garden could be displayed arranged separately on a page, like a formal diary, or dotted about at random. A good example of this is on page 106.

9

10

11

12

Ways of composing your painting

When planning a painting, your own studio practice will play an important role. As you become more familiar with your personal way of working and your likes or dislikes, you will be much clearer in your mind regarding what to do and how to do it.

Think of the shape of the finished painting and what it might look like in a mount and frame. Leave decent margins; either rule these in lightly and rub them out later, or mask off with paper. It is often worth using a sheet of paper larger than you think you need in order to give you the extra space.

Think about your natural preferences to help you in planning your compositions. It might be worthwhile to jot down a few notes about the subjects you are attracted to and your preferred size; the ways of displaying that appeal more than others and why; your thoughts on how to show a specimen; your comments on past or contemporary botanical paintings; and your views on the use of backgrounds. Traditionally, botanical subjects are portrayed without any background colour, but sometimes a background can indicate habit or environment, such as including leaf litter surrounding fungi. A picture can also be enhanced by indicating that the plant provides food for certain insects or fauna – butterflies around buddleia or hawk moths with privet.

Practise using a variety of ways to compose your painting. For example, you could place your items straight on to a sheet of white paper of the right size and move them around until you are happy with the grouping. Make notes on why you think some arrangements work better than others.

Some artists place the specimen on the paper and lightly mark the important details.

Or you could roughly paint and draw elements on cartridge paper or rough paper, cut them out, place the pieces on white paper and move them around. Try with some elements, then with fewer, then more.

Another method is to make photocopies or rough sketches, cut out and assemble as before, with different elements in different positions. If you have a light box, superimpose images over each other, or do likewise with tracing paper.

Some people like to fix paper to the studio wall and stick elements on to it.

Or you could simply take single items, place one on the paper, paint it, place another, paint it, and so on until the page pleases you – which is when you stop.

If you are a slower painter you can use all your reference material, sketches, detail drawing, colour and so on to build up a composition.

Right: Devil's tongue cactus
(*Ferocactus latispinus*). This cactus
was an extremely complex subject.
Numerous preliminary drawings
were made in order to place the
spines correctly.

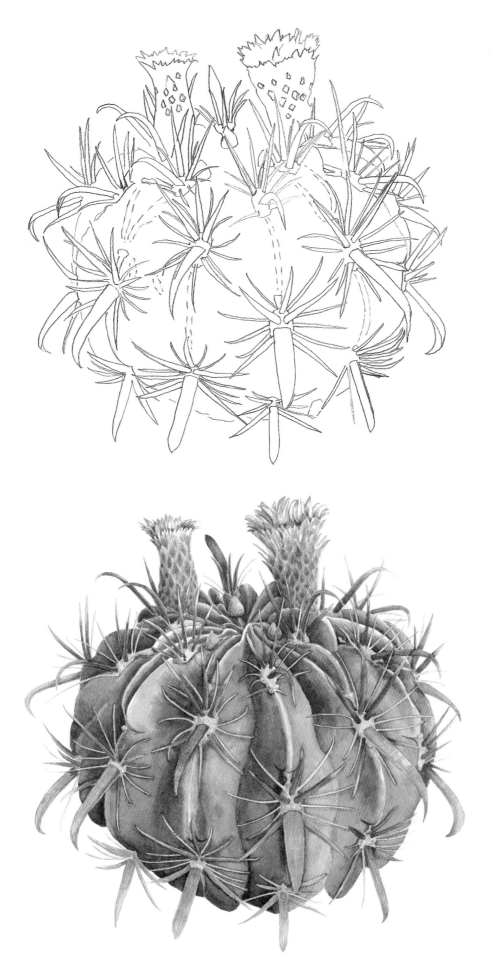

Practical composition exercise

For this exercise choose several plant pieces and consider various ways of presenting them. The following arrangements need attention:
- Try not to overcrowd the page with too much detail. Too many elements competing for attention can often lead to overload for the viewer.
- A painting should be well balanced, neither top- nor bottom-heavy.
- Elements such as leaves and stems should be contained within the margins and not appear to 'fly out of the picture', unless you have specifically calculated for a part or parts to leave the margins.
- Make sure the focal point is not too near to an edge.
- Elements such as leaves or roots should generally remain within the borders of the picture. If you have a subject with long, straggly leaves, for instance, consider portraying the leaves bent over so that they fit into and fill the space available on the paper. Alternatively a dramatic composition could feature all the leaves 'leaving the picture'.
- Make quick sketches using the same pieces in different positions. You may like to place pieces directly on to paper, or you could cut out corresponding shapes and move them around the page, drawing roughly around them. Another possibility is to make a display of plants, arranged in a block of oasis.
- Plants in a pot can be drawn from one angle then the position changed to incorporate a more stylish or sympathetic element, like a leaf or another flower or a bud. As long as this move is not detrimental to the species habit it is quite permissible.
- You may feel that you cannot know too much about composition. It is certainly true that, with greater understanding, even a heavily considered composition could be organized so as not to appear too 'contrived'.
- Because artists all work differently, no one person will plan and compose the same way as another. Some painters work so quickly that one or two specimens can be painted before the bloom droops. Others are much slower and consequently use a variety of strategies when planning and executing their work. Reference material such as watercolour sketches, detailed drawings, configuration variables, colour swatches, written notes and photographs can be vital to the successful outcome of the finished picture.
- The more you look at arrangements or compositions of botanical studies, or just groups of items in general, the more you will become used to seeing what works well or not so well. There are so many botanical paintings and so many ways of portraying plants to be found in books, in brochures and framed for viewing on walls; all have been composed or arranged. The possibilities are mind-boggling and can range from a small, dramatic portrait of a single flower to an all-over floral extravaganza.
- Finally, the rules, once known, can be broken. Sometimes the accepted norm can be altered and the 'frowned-upon' used to great effect. Experience will tell you whether something works or not.

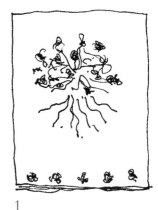

1

2

3

Above: Three arrangements of a plant with some enlarged features shown below it. 1) Too far apart; 2) Too close together; 3) Just right.

1

2

Above: 1) These cherries (*Prunus* spp.) were painted quickly, either singly or in small groups, on cheap layout paper. The groups were then cut out and arranged to form an interesting horizontal composition. 2) The finished painting.

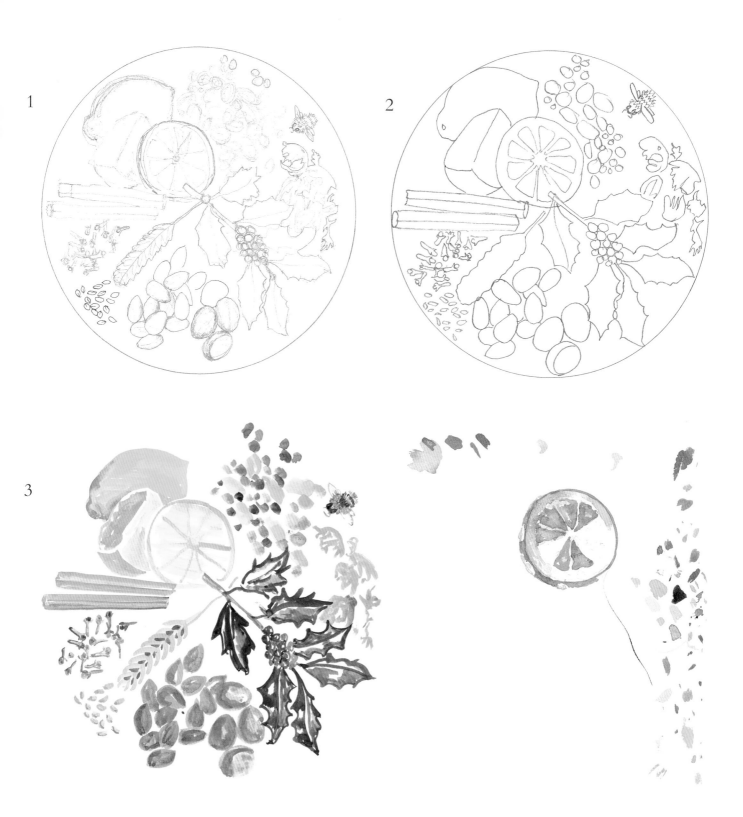

Above and Right: Christmas card 2004. The brief was to show the plant ingredients of a recipe for 'A good plumb cake' from *The Compleat Housewife* 1753 – crystallized lemon and orange peel, dried fruits, mace, nutmeg, almonds, flour (wheat), cloves, cinnamon – and honey, represented by the bee. And of course a sprig of holly. First the circle was drawn around a plate onto a sheet of layout paper. The artist felt that the ingredients should be given equal importance by fitting each roughly into a wedge shape, so they were all drawn separately, then cut out and placed within the circle (1). Once the layout was acceptable, a tracing was made (2), again on layout paper, and also a quick painting to check the colour balance (3). Finally the composition was lightly traced onto a sheet of Arches Aquarelle HP paper and the finished painting made. Even at this late stage, adjustments crept in – the bee buzzed over to the other side.

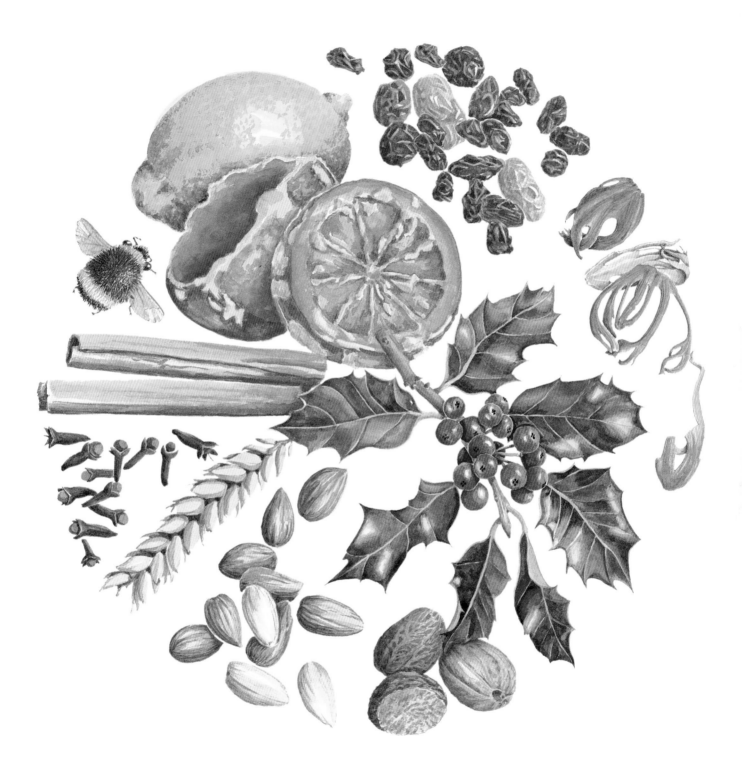

Postscript

As we said in the Introduction, we have aimed throughout this book to encourage you to try different ways of working, and in the process to discover your own strengths, weaknesses and preferences.

The course at the Eden Project in Cornwall, UK, on which this book was based was designed to take an academic year, with tuition on one day a week and plenty of homework in between. Each subject was given full attention; nothing was rushed.

You may have worked systematically through the book from chapter 1 to the end. Or you may have dipped into it, choosing chapters at random, depending on the availability of subject matter. Whatever you did, you will by now have mastered some techniques that you believed unconquerable. You may still be battling with others.

By continuing to expand your knowledge and skills by painting and by studying other artists' work, we hope that you will succeed in achieving the goal that made you pick up this book in the first place.

Rosie Martin
Meriel Thurstan

Further Reading

Benke, Brita, *O'Keefe*, Taschen, 2001. (ISBN 3822858617)

Blamey, Marjorie, *Learn to Paint Flowers in Watercolour*, HarperCollins, 1986. (ISBN 000412121X)

Blunt, Wilfrid and Stearn, William T,. *The Art of Botanical Illustration*, The Antique Collectors' Club, 1994. (ISBN 1851491775)

de Bray, Lys, *The Art of Botanical Illustration: The Classic Illustrators and their Achievements from 1550–1900*, Knickerbocker Press, 1997. (ISBN 1861604254)

Elliott, Brent and Hornby, Simon, *Flora: An Illustrated History of the Garden Flower*, Scriptum Editions, 2003. (ISBN 1902686330)

Evans, Anne-Marie and Donn, *An Approach to Botanical Painting in Watercolour*, Hannaford & Evans, 1993. (ISBN 0952086204)

Gombrich, Ernst, *The Story of Art*, Phaidon, 1972. (ISBN 0714815225)

Grierson, Mary, *An English Florilegium*, Thames & Hudson, 1987. (ISBN 0500234868)

Hickey, Michael, *Plant Names: A Guide for Botanical Artists*, Cedar Publications, 1993. (ISBN 0948640154)

Hickey, Michael and King, Clive, *100 Families of Flowering Plants*, Cambridge University Press, 1987. (ISBN 052123283X)

Hickey, Michael and King, Clive, *The Cambridge Illustrated Glossary of Botanical Terms*, Cambridge University Press, 2001. (ISBN 0521790808)

Hulton, Paul and Smith, Lawrence. *Flowers in Art from East to West*. British Museum Publications Ltd, 1979. (ISBN 0714100994)

Itten, Johannes, *The Elements of Color*, John Wiley and Sons, 1970. (ISBN 0471289299)

Le Fanu Hughes, Penelope, *History and Techniques of the Old Masters*, Tiger International Books. (ISBN 855010135)

Lewis, Jan, *Walter Hood Fitch: A Celebration*, HMSO Publications, London, in association with Royal Botanic Gardens, Kew, 1992. (ISBN 0112500668)

Mabberley, David, *Arthur Harry Church: The Anatomy of Flowers*, Merrel Publications Ltd, 2000. (ISBN 1858941164)

McLean, Barbara and Wise, Rosemary, *Dissecting Flowers*, Chelsea Physic Garden Florilegium Society, 2001. (ISBN 0953711420)

Mee, Margaret, *In Search of Flowers of the Amazon Forest*, Nonsuch Expeditions, 1988. (ISBN 1869901088)

Mee, Margaret, *Margaret Mee's Amazon: Diaries of an Artist Explorer*, The Antique Collectors' Club in association with The Royal Botanic Gardens, Kew, 1999. (ISBN 1851494545)

Robertson, Pamela, *Charles Rennie Mackintosh: Art is the Flower*, Pavilion Books, 1995. (ISBN 1857933605)

Royal Academy of Arts, *Post Impressionism*, Weidenfeld & Nicolson, 1979. (ISBN 0297777130)

Sherlock, Siriol, *Exploring Flowers in Watercolour: Techniques and Images*, B T Batsford, 1998. (ISBN 0713480246)

Sherlock, Siriol, *Botanical Illustration: Painting with Watercolours*, B T Batsford, 2004. (ISBN 071348862X)

Sherwood, Shirley, *Contemporary Botanical Artists: The Shirley Sherwood Collection*, Weidenfeld & Nicolson in association with The Royal Botanic Gardens, Kew, 2003. (ISBN 0297822705)

Sherwood, Shirley, *A Passion for Plants: Contemporary Botanical Masterworks*, Cassell & Co., 2001. (ISBN 0304358282)

Stearn, William T., *Flower Artists of Kew*. The Herbert Press in association with The Royal Botanic Gardens, Kew, 1997. (ISBN 1871569168)

Stewart, Joyce and Stearn, William T., *The Orchid Paintings of Franz Bauer*, The Herbert Press in association with the Natural History Museum, London, 1993. (ISBN 1871569583)

West, Keith, *How to Draw Plants: The Techniques of Botanical Illustration*, A&C Black, 1999. (ISBN 071365273X)

White, Christopher, *Dürer: The Artist and his Drawings*, Phaidon, 1971. (ISBN 0714814369)

Wunderlich, Eleanor B., *Botanical Illustration in Watercolour*, Watson-Gupthill Publications, New York, 1996. (ISBN 0823005305)

Zomlefer, Wendy B., *Guide to Flowering Plant Families*, University of North Carolina Press, 1994. (ISBN 0807821608)

Useful information

Recommended paints

Daler Rowney artists' quality
Holbein
Lefranc et Bourgeois
Old Holland Classic
Sennelier
Schminke–Horadam
Winsor & Newton artists' quality

Recommended paper (HP or not)

Arches Aquarelle
Fabriano 5 or Artistico
Lana Aquarelle
RWS (Royal Watercolour Society)
Saunders Waterford
Schoellershammer
Sennelier Aquarelle
Winsor & Newton

Recommended brushes

da Vinci Maestro series 10 and 35
Escoda
Isabey
Raphael
Winsor & Newton series 7

General art supplies

Ken Bromley Art Supplies
Curzon House
Curzon Road
Bolton
BL1 4RW
United Kingdom
Tel: 01204 381900 (International +44 1204 381 900)
Fax: 01204 381123
Lo-Call Rate Tel: 0845 330 32 34
e-mail: sales@artsupplies.co.uk

Jackson's Art Supplies
1 Farleigh Place
Farleigh Road
London N16 7SX
Tel: 0870 241 1849 (International +44 207 254 0077)
Fax: +44 207 254 0088
email: sales@jacksonart.com
www.jacksonart.com

T N Lawrence & Son Ltd
208 Portland Road
Hove
BN3 5QT
United Kingdom
Tel: 0845 644 3232 (+44 1273 260260)
Fax: 0845 644 3233 (+44 1273 260270)
E-mail: artbox@lawrence.co.uk

Also at:
Redruth
Cornwall
TR15 3RQ
United Kingdom
Tel: 0845 644 3232

Pearl Paints North America Inc.
1-800-451-7327 (open from 9 a.m. to 12 midnight eastern time)
PEARL Attn: Bid Dept
1033 E. Oakland Park Blvd.
Fort Lauderdale, Florida 33334 USA
Email: orders@pearlpaint.com
www.pearlpaint.com

Lefranc et Bourgeois
www.lefranc-bourgeois.com

Digital Art Supplies
www.digitalartsupplies.com

Art Discount
www.artdiscount.co.uk

Note: Details correct at time of going to press

Acknowledgements

It is humbling to see how many people have allowed themselves to become involved in the production of this book.

At the Eden Project we owe thanks to Carolyn Trevivian and Mike Petty for their general advice and to Alistair Griffiths and Tim Pettitt for checking our botanical facts – any mistakes that may have slipped through are ours, not theirs. We are grateful to Iain Prance and Tim Smit for endorsing the book so enthusiastically; and to Roger Wasley, Maureen Newton, Jann Coles, Dee Tizzer and all the staff at Eden's Watering Lane Nursery for their hospitality and enthusiasm while we were running the Diploma course.

To our students, Lyn Aldridge, Elaine Baigrie, Carolyn Frea, Kevin Frea, Jan Gowthorpe, Clare Holmes, Suzy Maxwell, Maria Porter, Liz Rousell, Christopher Salter, Georgie Smith and Christine Thomas, a big thank you for making it all so much fun.

Thanks go to Tina Persaud, Helen Evans, Kristy Richardson and all at Anova Books for leading two complete novices through the publishing experience with such gentleness and kindness.

And finally, we would like to thank everyone who has read the text and added their own comments, especially David Barwick for his technical advice and Alan Greenwood, 'Fibonacci Man', who gave Rosie detailed notes while they were observing icebergs north of the Arctic Circle in July 2004.

Picture credits

Particular thanks are due to the following for illustrative material: Lyn Aldridge 30 (bottom right), 69, 79, 82, 83, 87, 90, 91, 109, 125, 135; Carolyn Frea 71; Jan Gowthorpe 55 (bottom), 58; Clare Holmes 6; Maria Porter 25, 111 (bottom); Liz Rousell 11, 33, 36 (left), 37, 56, 59, 86, 89, 92, 94, 102, 103, 104, 105, 106, 107, 113 (bottom); and Georgie Smith 38, 76, 77, 113 (left), 118. All other material is by the authors.

Index